El Greco

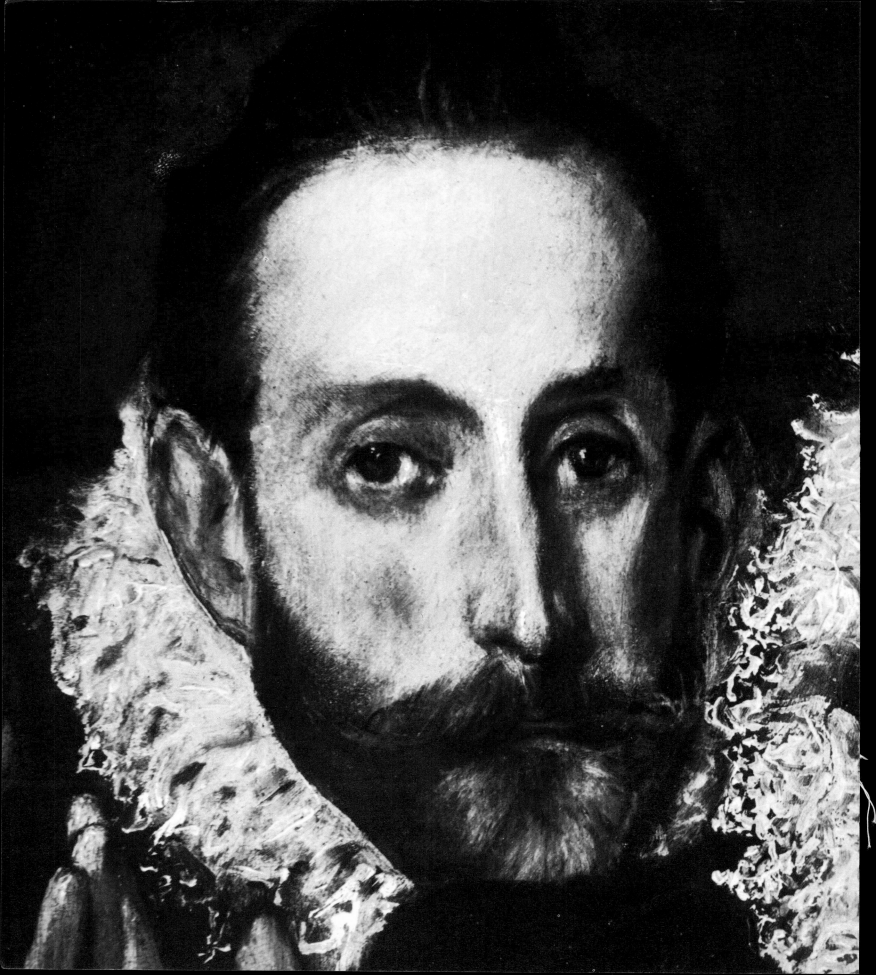

Philip Troutman

El Greco

The Colour Library of Art

Hamlyn
London · New York · Sydney · Toronto

Acknowledgments

The paintings in this volume are reproduced by kind permission of the following collections, galleries and museums to which they belong: Art Institute of Chicago; Gift of Nancy Atwood Sprague in memory of Albert Arnold Sprague (Plate 8); Art Museum, Cincinnati (Plate 34); Chapel of San José, Toledo (Plate 26); Chapter House, Monastery of El Escorial (Plates 14, 15); Church of Santo Tomé, Toledo (Plates 16, 17, Figure 1); Cleveland Museum of Art, Ohio. Gift of the Friends of the Cleveland Museum of Art, in memory of J. H. Wade (Plate 20); Dumbarton Oaks, Washington D.C. (Plate 45); Frick Collection, New York (Plate 7, Figure 4); Galleria Estense, Modena (Plates 1, 2); Hospital de la Caridad, Illescas (Plates 38, 39, 40, 41, 42); Hospital de San Juan Bautista, Toledo (Figure 5); Institute of Arts, Minneapolis (Plate 5, Figure 2); John G. Johnson Collection, Philadelphia (Plate 6); Mrs Maxwell MacDonald, Pollok House, Glasgow (Plate 11); Metropolitan Museum of Art, New York. Bequest of Mrs H.O. Havemeyer, 1929. The H.O. Havemeyer Collection (Plates 29, 32); Metropolitan Museum of Art, New York. Rogers Fund, 1956 (Plate 48); Monastery of El Escorial (Plate 46); Museo Balaguer, Barcelona (Plate 22); Museo del Greco, Toledo (Figures 3, 6); Museo Nacional del Prado, Madrid (Plates 9, 18, 23, 24, 25, 33, 49); Museo Nazionale di Capodimonte, Naples (Plate 4); Museo Provincial, Seville (Plate 35); Museo de Santa Cruz, Toledo (Plate 44); Museum of Fine Arts, Boston (Plate 43); Trustees of the National Gallery, London (Plates 13, 31); National Gallery of Art, Washington D.C. Gift of Chester Dale (Plate 47); National Gallery of Art, Washington D.C. Samuel H. Kress Collection (Plate 30); National Gallery of Art, Washington D.C. Widener Collection (Plates 27, 28); Nelson Gallery, Kansas City. Atkins Museum. Nelson Fund (Plate 12); Pinacoteca Stuard, Parma (Plate 3); Sacristy of Toledo Cathedral (Plates 10, 37); Toledo Museum, Ohio (Plate 21); M.H. de Young Memorial Museum, San Francisco. Samuel H. Kress Collection (Plates 19, 36). The following photographs were supplied by Ampliacciones y Reproducciones Mas, Barcelona (Plates 9, 10, 16, 17, 18, 22, 33, 35, 41); André Held – Joseph P. Ziolo, Paris (Plates 14, 15); Michael Holford, London (Plates 31, 39); Picturepoint, London (Plates 3, 49); Scala, Florence (Plates 1, 2, 24, 25, 26, 38, 40, 42, 46); Vaghi, Parma (Plate 3); A. J. Wyatt, Philadelphia (Plate 6). The frontispiece is reproduced by courtesy of the Mansell Collection, London.

1 Frontispiece. Self-portrait. Detail from *The Burial of the Count of Orgaz*. 1586. Oil on Canvas. Signed. Church of Santo Tomé, Toledo (Plate 16).

Published by
THE HAMLYN PUBLISHING GROUP LIMITED
London · New York · Sydney · Toronto
Hamlyn House, Feltham, Middlesex, England

© copyright Paul Hamlyn Limited 1963
Revised edition 1967
Reprinted 1969
Paperback edition 1971

ISBN 0 600 33052 4

Printed in Italy by Officine Grafiche Arnoldo Mondadori, Verona

Contents

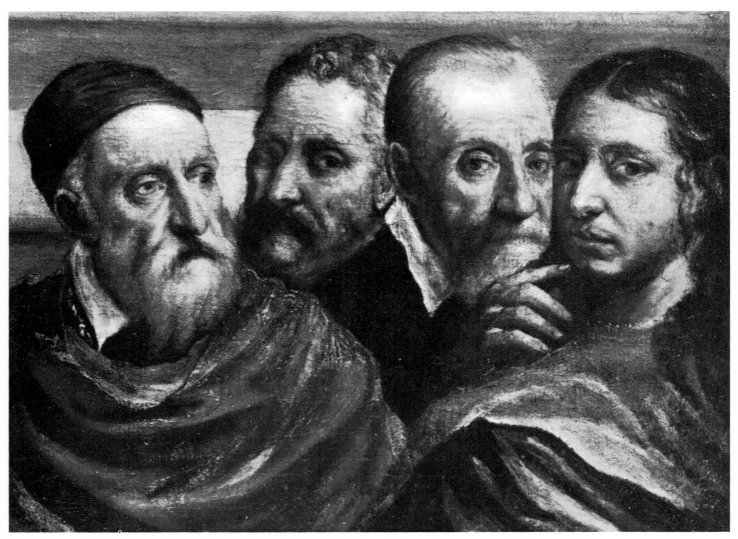

2 Titian, Michelangelo, Giulio Clovio and El Greco. Detail from *Christ Driving the Traders from the Temple*. 1571-76. Oil on canvas. Signed. Institute of Arts, Minneapolis. (Plate 5).

Introduction

'*Crete gave him his life...*' (Paravicino, on the death of El Greco, 1614.)

The first great Spanish painter was not born in Spain, but in the Greek island of Crete in the eastern Mediterranean. If the testimony he made towards the end of his life is true, Domenicos Theotocopoulos – for that was his name – was born in 1540 or 1541. Even this, however, is open to some doubt, for all other indications are that he was born some few years later. In vain we seek to know something of the young Domenicos in Crete, where it seems he spent his childhood and his youth, for there is absolutely no information.

One thing is certain, that those years on the Greek island made a deep and permanent impression upon him; an impression concealed during the years of his early manhood spent in Italy in examining the infinity of new impressions of Western Renaissance culture, but whose spirit is remembered in his later years when he was so far from the land of his birth. It is the significance of his Byzantine and medieval origins that Paravicino, the great Toledan poet, acknowledges in his sonnet written on the passing of his friend, the great 'Toledan' painter.

While nothing is known of his parents, or of the Theotocopoulos family, there is every indication that his family was of some status, and able at least to provide a liberal education for Domenicos. It is clear that he was given a thorough schooling in the Greek language and letters, a study which he was to cultivate throughout his life. Francisco Pacheco, the erudite painter and poet from Seville, Velasquez' master and father-in-law, who visited the aged El Greco in Toledo in 1611, tells us he was a 'great philosopher, quick and discerning in his remarks', and the library left on his death contained many works of the Greek philosophers and poets as well as devotional works in his native tongue. There is the same evidence that in Italy he applied himself to the study of the Italian philosophers and poets.

It was almost certainly in Crete, too, that he received his first artistic training, and possibly in the monastery of Saint Catherine, the most important school of painting on the island, to which he seems to make reference in the first work known by his hand, the *Modena Triptych*, painted in Italy. Monasteries were the only places of learning and ar-

tistic training in Crete, still medieval in its culture and linked with the East, and little affected by the great Renaissance in Italy. In Italy the past two and a half centuries had seen the establishment of an entirely new culture, and all the Western world was awake to the new ideas. In Crete, however, Byzantine art still flourished – the kind of art practised in Italy by Duccio, who had died some two hundred years before.

The grand, hieratic, abstract images of Byzantine art, in mosaic or miniature, powerful and impressive in their design and colour, had the authority of a millennium of development, and were the expression of the spirit of a whole society. A comparable impression and authority speak from the designs of El Greco's maturity. We shall probably never know what his Cretan paintings were like. If indeed he was trained as a painter in Crete, they would have been very different from his earliest known works, painted soon after his arrival in Italy.

'*A young pupil of Titian's...*' (Giulio Clovio, letter to Cardinal Farnese, 1570).

At the end of the fifteenth century, in the reign of the Catholic sovereigns, Ferdinand and Isabella, the Moors were finally expelled from their last dominion in Spain, some seven hundred years after their first invasion of the peninsula; at the same time there began the real invasion, in the eastern Mediterranean, of Europe by the Turks, that was not to be halted until it reached Vienna. The incursion of the Turks, which threatened Crete, encouraged an exodus from the island, and among those who left was the young scholar and painter.

The earliest known document relating to him, the letter from Giulio Clovio dated 1570, refers to him as a pupil of Titian. It was natural for a Cretan to make for Venice, for the island was a Venetian dominion. At that time the city was the new home of thousands of 'Greeks' from the Venetian territories of the eastern Mediterranean, and the presence of so many 'Grechi' in the city adds to the difficulty of tracing reference to one individual: Domenicos Theotocopoulos now becomes simply 'il Greco'.

The time of the young Domenicos' removal to Venice

could not have been more favourable. It was the time of the apogee of Venetian painting, when Titian, Tintoretto and Veronese were all working in the city. It must have been an immense inspiration to work with the great master of colour. Titian was in his eighties and working in his last grand manner, and on the death of Michelangelo, his only peer, in 1564 in Rome he was the greatest living artist. The year 1564 was possibly not far from the date when El Greco entered his studio.

Perhaps he had the added inspiration of aiding Titian in his important commissions for Philip II of Spain, for in 1567 the master refers to a young pupil assisting him on the *Martyrdom of Saint Lawrence*, the great masterpiece of his last years destined for the Escorial. At this time El Greco would have heard of the Spanish King's vast project of the Escorial, the monastery and palace which had begun building in 1563, from which the King was to direct his great crusade for the Faith – directed against the heretic at home, the Infidel in the Mediterranean, and towards the conversion of the heathen in the Indies; for the King was seeking painters to decorate his great enterprise. His first feelings of sympathy for the Spanish spirit probably originated at this time: Spain too had been close to the Orient, and had not completely broken with the medieval world, and she could appear at this moment as the one real champion of the Faith. It was to be a long time, however, before he moved to Spain.

He had entered a new world, and was confronted with an infinity of new impressions which he eagerly sought to understand. The ideas and meaning of this new world were as important to the young scholar and painter as their expression in painting. Among the painters he looked to for inspiration, Titian was, if the most important, by no means the only one, and the nature of El Greco's studies in Venice indicates a strong personality with a sense of his own special gifts. He seems to have arrived with no preconceived respect for the authority of an established style or personality, or indeed for the new culture. His attitude, however, does not imply disrespect, but rather a desire to comprehend his new environment. His works in Venice show him trying out the new subject-matter, its new interpretation, and the new techniques.

He was by no means a great artist in Venice. The panels of the *Modena Triptych* (plates 1 and 2), his earliest work known, could easily be by any one of a number of provincial 'Greek' artists working in the city. It is a work that unfortunately tells us nothing of his painting in Crete. Painted probably not long after his arrival in Venice, there is nothing in it that is transitional. For the flat and relatively rigid geometrical designs of Byzantine art he has substituted the looser, more naturalistic and three-dimensional designs of Italian and Venetian inspiration. The compositions are not original, being borrowed from a variety of sources probably through engravings. The art of engraving had developed considerably in the first half of the sixteenth century and was of inestimable value to a young artist seeking to acquaint himself with the achievements of European art.

The remaining few paintings bear witness to the broad source of his inspiration. He made his own the freedom of the Venetian 'open' technique, of which his master was the supreme exponent. He essays Tintoretto's style, with its employment of space and movement as dramatic elements of the design (plate 3). Later, in his efforts to express another reality, that of the spirit, he was to throw aside those dramatic empty spaces and violent perspectives; movement, however, was to remain an essential part of his painting. Similarly, he introduces himself to the possibilities of light as a dramatic element in design, especially perhaps by reference to Bassano; but the naturalism and rustic atmosphere of the Venetian's paintings he found irrelevant, as indeed he could feel little sympathy generally for the Renaissance Italian concession to a human, temporal or local interpretation of the universal and spiritual.

There was little that he did not try out in Venice, and little specifically he could make his own. Nevertheless, it was in Venice that he was introduced to a free technique, to a painting that believed in the primacy of colour, and to the dramatic possibilities of light and movement, that is, to the essential bases of his technique.

'*There has just arrived in Rome a young painter...*' (Giulio Clovio, letter to Cardinal Farnese, 1570.)
In 1570, the first certain date in El Greco's biography, he moves to Rome, the capital of the Christian world, and the

great artistic centre of Italy, where Michelangelo had only recently died. It was there that he was to complete his artistic training and his introduction to the new ideas of the West.

Giulio Clovio, a 'Greek' from Croatia, introduces the young Cretan to Cardinal Alessandro Farnese, to whom he was artistic adviser and in whose famous library he was employed as a miniaturist. We do not know El Greco's self-portrait that Clovio so highly extolled, but his report probably shows some over-enthusiasm for his young friend. El Greco does, indeed, prove himself an able follower of Titian in the portrait of Giulio Clovio (plate 4), probably painted soon after his arrival in Rome, but there is little anticipation of the individual quality of his later works which make him one of the few really great portrait painters of all time.

His introduction to the Cardinal did lead to some patronage, although he does not appear to have received any important commissions in Rome, nor does it seem that the 'young' artist who stayed in the Farnese Palace – he was apparently nearly thirty years of age when he arrived in Rome – had any need to seek commissions for his livelihood. In fact, almost all his paintings in Italy were very small, many of them almost miniatures, and only in Rome are there two or three portraits and one or two compositions of less modest size. What was of consequence to him was his introduction to the circle of scholars and men of religion who frequented the Farnese Library, and also the new impressions of the formal art of Rome.

If El Greco's attitude when he first arrived in Italy was remarkable, his almost naive integrity was even more startling in Rome. The memory of Michelangelo was almost sacred, and had produced something of an artistic tyranny in the city, where nobody could easily question the learned and inhibiting theory that purported to understand and give authority to his style. If the style it encouraged was appropriate to the frigid and correct exposition of dogma, one of the consequences of the deliberations of Trent, it had little to recommend itself to El Greco. He questioned the very basis of its ideal figure art, with its insistence on the primacy of form and drawing, to which colour was a mere adjunct. He could have had even less sympathy for the importance attached to the study of anatomy by contemporary artists in Rome. Similarly the construction of space according to mathematical rules of perspective, although employed in an irrational way by the Roman Mannerists, meant little to him.

Nevertheless, as in Venice, he was able to profit greatly from his stay in the Holy City. Above all, he could derive much from the spirit, if not the letter, of the High Renaissance, especially from Raphael and the early Michelangelo, and his paintings in Rome gain in largeness of conception (plate 5). He was also possibly the only artist of his time to appreciate Michelangelo's late style. If Venice had introduced him to so much that was important, Michelangelo's inspired and individual treatment of form in his last years indicated to El Greco the infinite possibilities of the more flexible technique of painting. The small *Pietà* (plate 6) is a direct interpretation in paint of Michelangelo's late sculptured group now in Florence Cathedral, and then in Rome.

In the group of portraits in the *Christ Driving the Traders from the Temple* (figure 2), he acknowledges his debt both to Michelangelo and Titian, and possibly also to Raphael. The painting, first composed in Venice, loses much of its loose, disturbed quality, by contact with Rome. In his compositions in Rome and his first years in Spain, he employs figures directly inspired by the heroic style of Michelangelo (especially plates 9 and 14). Later they were to go, once he was able to replace them by his own.

Contemporary Roman Mannerist painting was also not without its fruitful influence: the vertical compositions and shallow construction of space pointed the way to the elimination of three-dimensional space (plate 14), while the combination of the more vivid and less natural colour of Rome with the richer, more substantial colour of Venice helped to lay the basis of his own personal and dramatic use of colour.

It is clear that he had very little in common with the painters of Rome. Neither could he be entirely in sympathy with the Humanist atmosphere of the Papal City: the 'divine' of Michelangelo was a reference to the gods of pagan mythology, as the conception of the heroic was derived from the spirit of ancient history and myth. El Greco's prototype of the great artist was to be Saint Luke; his prototype of the heroic, the great martyrs of the Faith. To El Greco,

the Roman brand of Humanism celebrated the greatness of Man himself – of the individual – on account of his material potentialities; El Greco, from medieval Crete, believed in importance of Man because of his unique spiritual being, through which, alone, the meaning of the Universe could be fulfilled. His discussions with the Spanish Humanists in the Farnese Library would have indicated an attitude in Spain – where it was possible for the great Gothic cathedrals of Salamanca and Segovia to be erected at the same time as the Escorial – closer to his own, and it was from them that he received his first important commission, and the opportunity to go to Spain. The news, received in Rome in 1571, of the great victory over the Turk at Lepanto, off the Greek mainland, must have encouraged some sympathy in the Greek artist for Spain's crusade, as later it was to inspire his *Adoration of the Name of Jesus* (plate 13).

It is unnecessary to believe that he was forced to leave Rome on account of the hostility of the artists caused by his presumption in offering to paint a 'Last Judgment' not inferior to Michelangelo's, if the work were pulled down, as related by Mancini some half a century later. At the time that El Greco was in Rome there were proposals to cover up the 'indecent' parts of Michelangelo's great work in the Sistine Chapel, composed entirely of nude figures, and Mancini no doubt merely relates a rumour, which however, certainly reflects something of El Greco's attitude.

Rome was unpropitious to his genius. In 1576 he received the offer of an important commission for Toledo to provide altarpieces for the church of Santo Domingo el Antiguo, made by the Dean of Toledo Cathedral through the agency of his brother in Rome, and he accepted – surely with the hope eventually of working for the Escorial.

'To express my gratitude, I agree to accept 1000 ducados instead of the 1500 offered...' (El Greco, in the agreement for his first commission in Spain, 1577.)
Certainly the Dean's brother must have given a good account of the painter, for immediately on his arrival in Toledo and before starting the work for the church of Santo Domingo, he was commissioned to paint the *Espolio* for the Cathedral. For the first time he had been given the opportunity to paint on a monumental scale. To express his pleasure at seeing the fulfilment of his ambition so near he offered to accept the small sum of 1000 *ducados* instead of the 1500 offered for the work for Santo Domingo, which involved the designing of the whole scheme of decoration. The two commissions were to occupy him fully for two years, and their importance inspired him to produce a whole series of masterpieces (plates 8-10).

He was now thirty-five years of age. In Italy, he had completed his artistic training, and he no longer needed to look to art for his inspiration. The first real application of the lessons learnt was not until he arrived in Spain, and his painting really began with these two commissions.

Each painting was treated as a separate problem, as indeed later each subject was to decide its own appropriate colour, light, pattern and rhythm. In the first work, the *Assumption*, he seeks to treat in his own way a composition finally of Venetian inspiration; in the second, the *Trinity*, it is a composition essentially inspired by Michelangelo, and a grand development of his own *Pietà* painted in Rome. In the *Adoration of the Shepherds*, the problem is especially that of light; and in the *Resurrection*, dramatic movement, and a more supernatural light. In *Saint John the Evangelist* he attempts to express the heroic in his own way; and the majestic Christ of the *Espolio* is the first of his completely personal images, in which pattern, movement and colour, type and gesture are in complete harmony, and in accord with the one expression. This painting is also the one of greatest variety and vitality in the handling.

In all these paintings, he begins to develop his own expressive colour. Colour and light begin to combine, and take on a quality of flux. Space is little more than implied, and the distinction between sky and earth goes: the motifs of the open tomb of the *Assumption*, the rocks of the *Resurrection* and the ground of the *Espolio*, do not disturb the essential verticality of the compositions. The figures have lost much of their corporeality, but not their grandeur, by their surface treatment in colour and light. In this development, the nude figure of Christ of the *Trinity*, inspired by Michelangelo's heroic figure style is the least advanced, and the single draped figure of *Saint John the Evangelist*, the most advanced. Draperies are indeed at this stage treated more freely than

the figures, and they become an expressive element in themselves. Both shade and light are active in colour, and if they still imply modelling of the forms, they do not stress the quality of relief.

Each composition is inspired by its appropriate movement: the grand slow tempo of the soaring image of the Virgin of the *Assumption*; the urgent and arrested rhythm of the shepherds of the *Adoration*; and above all the tremendous contained movement of the Christ of the *Espolio*. Movement was to be an essential element of his painting.

All the paintings are full of reminiscences of Italy, and it is some few years before they disappear. He has, however, started on the path he was to follow to its conclusion, and the advance made during the two years was immense. If he were to express the spiritual, it would be by other than material means, and the process of dematerialisation has begun. Neither corporeality, nor a distinction between earth and sky, belonged to the realm of the spirit; neither could the ideal figure art of Rome with its pagan implications, nor the sensual art of Venice with its temporal concessions, be reconciled to the expression of his view of the essential spiritual meaning of the Universe. He now sought to create a painting from colour and light, pattern and movement, and without any direct reference to the art of the past or present.

His unyielding attitude before interference with his artistic interpretation of a subject is brought out in the arguments over the valuation of the *Espolio*; El Greco ignored the demands made by the Cathedral authorities – probably largely to support a low valuation – to make certain drastic changes to his painting. The remarks of El Greco's valuers, when he finally agreed to accept about a third of the previous valuation, that 'if the painting should be valued at its true worth, there would be few or none prepared to pay', express the startling impression made on the artists in Toledo by El Greco's first works.

Shortly after he arrived in Toledo he must have made acquaintance with a Spanish lady, Jerónima de las Cuevas, who became his life-long companion, and who in 1578 gave him a son, Jorge Manuel, to whom he became a devoted father. All we know of the lady whom he never married is the sympathetic portrait painted apparently at the beginning of their acquaintance (plate 11). He introduces us

to his son on a number of occasions (plates 16, 35 and 38).

'*His painting did not please the King...*' (Sigüenza, History of the Jeronymite Order, 1608.)
El Greco was recognised as an artist of outstanding merit, and he had met with sympathetic patrons. In 1579, immediately after the conclusion of his first commissions for Toledo, the long-desired opportunity to work for the Escorial was offered him. He had already painted the *Adoration of the Name of Jesus* (plate 13) for the King, and was now invited to paint specifically for the Escorial. Navarrete had died, and Philip II was looking for someone to replace the painter he so admired. El Greco put everything into the painting, the *Martyrdom of Saint Maurice and his Legions* (plate 14), and had produced a work of astounding power and originality. Already in the *Espolio*, he had daringly introduced the grand passage of vivid red in the mantle of Christ; in the *Saint Maurice*, an intense blue animates the whole composition. The complementary strident yellow enhances the powerful and moving impression. Before he started to work on the picture he had already decided on the colour that would best symbolise the event, and this consideration becomes an essential in all his subsequent painting.

He worked for two years on the painting: if he were successful, his great ambition would be fulfilled. But he was to be disappointed. The splendid masterpiece of painting did not please the King, who commissioned another artist to make a substitute. El Greco turned to his first patrons in Toledo, and he was not given another opportunity to work for the King.

It was perhaps inevitable, and, in the event, it was fortunate. His genius was too independent to serve the austere and rigid demands of the Escorial. His art, also, was not concerned with the militant aspect of religion, in which the Inquisition and its *autos-da-fé* played so important a part in Spain at that time. But in Toledo, the great cultural and ecclesiastical centre of Spain, he was to find a sympathetic atmosphere, a select circle of friends among the men of religion, scholars and poets of the town, and an appreciative and loyal clientele. The poets Góngora and Paravicino were among his friends; the great mystics Saint Teresa of Jesus and Saint John of the Cross visited the town. It was a time

3 *Saint Bernardino.* 1603. Oil on canvas. 106×45¼ in. (269×144 cm.). Signed. Museo del Greco, Toledo.

in Spain of great religious fervour and spiritual activity – possibly found in its most concentrated form in Toledo – which reached its climax in the years El Greco was in the town.

'*The citizens of Toledo never tire of seeing his painting…*' (Alonso de Villegas, *Flos Sanctorum*, 1588.)

The failure at the Escorial closed five years of uninterrupted activity in Spain. There followed several years of respite before any comparable commissions came his way. For El Greco this was a period of reflection, the outcome of which was the final declaration of his aesthetic. If his efforts before were particularly directed towards preparation for the Escorial, his time was now employed in getting to know more intimately the atmosphere of Toledo, in meeting with kindred spirits, and in coming to terms with himself. He finally succeeds in eliminating all direct references to the art of Venice and Rome, and the process of dematerialisation is continued.

To this period belong the *Saint Mary Magdalene* (plate 12), which still reveals its Venetian, specifically Titianesque, inspiration, and the *Saint Sebastian* (Palencia Cathedral) whose Roman derivation is still apparent. At this time too he painted the *Immaculate Conception with Saint John* (Museo de Santa Cruz, Toledo), in which for the first time there is a clear recollection of his early impressions of Byzantine art. These are, however, among the last paintings to make any clear references to the art of Byzantium, Venice or Rome.

His first completely personal work, the *Burial of the Count of Orgaz* (plate 16), was painted in 1586, when he was forty-five. In this painting any description of space, or of the corporeality of the figures, has completely gone, allowing an undisturbed expression of the spiritual atmosphere of the scene, and of the spiritual or psychological presence of the participants. To El Greco there could not be the easy concession of depicting Heaven and Earth as two separate things, physically distinct as the earth and sky. To him, as to a Saint Teresa of Jesus, the spiritual was omnipresent: it was present in the celestial visitors who lay the body to rest, and expressed in the remarkable pattern formed by the two Saints and in the colour of their vestments; present in the souls of men, and realised in the activity of the earthly

participants in the miraculous event; pervading the whole scene, and expressed in the variety, splendour and activity of the colour and light. To him the spiritual was the only significant reality.

There is absolutely no confusion, but a grand equilibrium, yet movement is an essential part of the expression: the composition, shapes, gestures, colour and light are made active and living symbols. These separate elements, and the particular rhythm that informs them, derive from the meaning of the supernatural image or event. Henceforth, El Greco was to express the spiritual by strictly extra-natural means, and the development of his painting was in the direction of a greater simplification of the means and a greater concentration of the expression.

If the popular success of *The Burial of the Count of Orgaz* depended largely on the 'like-life portrayal of men of Toledo of his time', he had become, for his life-time at least, an almost legendary figure to Toledans.

After the completion of the painting some ten years were to elapse before, in 1596, he was again given any comparable commissions. It was nevertheless a period of great activity, in which he was engaged on a host of smaller commissions. In this decade he formulated his repertoire of subjects and worked out their individual interpretation.

Painting in Spain in the sixteenth century, still partly medieval in character, was almost totally confined to religious subjects, and especially concerned itself with the devotional image. El Greco was in sympathy with this. He did not so much extend the range of subjects as revivify them, giving meaning and reality to the images.

The Old Testament does not figure in his repertoire of subjects, which concerns itself with the central personalities and mysteries of the Faith, in which were embodied the essential meaning of the Universe. The mysteries were those which expressed the essence of the spiritual, essentially divorced from ordinary human experience: the Virgin of the Annunciation (plate 22) receiving the Spirit, and the Christ on the Cross releasing the Spirit (plate 23); the Christ of His Mystic Birth and of the Resurrection; the Christ of the Baptism (plate 24) and the Pentecost (plate 25), both themes of the descent of the Spirit. These six subjects he composed together in the grand unified programme dedicated to the

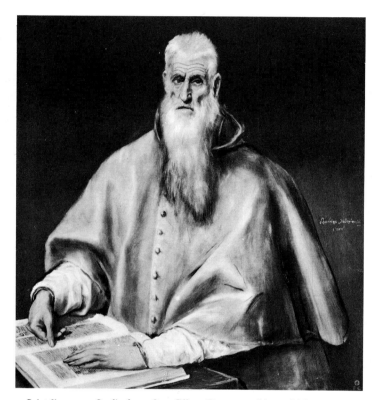

4 *Saint Jerome as Cardinal.* c. 1600. Oil on Canvas. 43⅝ × 37⅝ in. (111 × 96 cm.). The Frick Collection, New York.

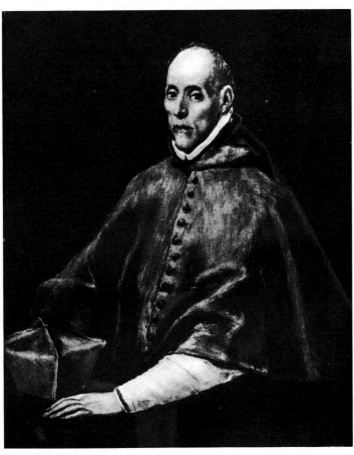

5 *Cardinal Juan de Tavera.* c. 1610. Oil on canvas. 40½ × 32¼ in. (103 × 82 cm.). Hospital de Tavera (Hospital de San Juan Bautista), Toledo.

'life of Christ', for the Colegio de Doña María in Madrid (plates 22 to 25). It is clear that he must have played an important part in the devising of the programme, and as certainly in its interpretation.

In his interpretation of these subjects, the grand poetry of the Holy Scriptures was an integral and essential part of the mystery, and it is expressed in the setting as in the whole pictorial conception. The apocalyptical character of his painting increases, and it is appropriate that two of his last works were the *Immaculate Conception,* the great masterpiece of his last years, and a subject of purely supernatural implication, which he related to Saint John's vision of the Apocalypse, *The Vision of Saint John the Divine* (plate 48). In both of these works he supremely realises the tremendous visionary poetry of the Revelations.

An important place in his repertoire of subjects was taken by the image of Christ, the Virgin and the Saints near to Christ. These images were of two types. The one is the simple image of the Saint, in which he sought to express by a characteristic type and gesture, and by pattern, colour and movement, the essence of the personality and its meaning. To this category belong the *Saints Francis and Andrew* (plate 18), *Saint Bernardino* (figure 3), *Saint John the Baptist* (plate 36) and the late *Saint Peter* (plate 46), possibly the grandest of all. The other type is that of the Saint in ecstasy or inspired, and related to some specific and characteristic situation. Of this type are the penitent *Saint Mary Magdalene* (plate 12 is an early painting), *Saint Jerome* (plate 47), the *Saint Francis receiving the Stigmata,* and the *Saint Ildefonso* inspired writing his dissertation on the Purity of the Virgin (plate 42). The two last Saints are unexpected in his repertoire, which otherwise confines itself to the New Testament, but their presence can be explained by the closeness to Christ of Saint Francis who receives the Stigmata – there is little of the human, 'gentle' Saint – and the fact that Saint Ildefonso was the patron Saint and the first Bishop of Toledo.

The idea of the pairs of Saints which appear at this time was not his own, and he would have known the great series painted by Navarrete for the Escorial. El Greco introduces them into his repertoire in the 1590s, and the juxtaposition of two different personalities in the one painting was an invaluable exercise in bringing out the character of each.

Saint Peter and Saint Paul, the two Saint Johns, were obvious pairs, but he also brings together such diverse characters as the *Saint Andrew and Saint Francis* (plate 18).

'*Toledo was more propitious to his genius...*' (Paravicino, on the death of El Greco, 1614.) Paravicino, in his sonnet dedicated to his friend, recognises the great significance of the atmosphere of Toledo to the great painter, and El Greco confesses his debt to the town by introducing into his paintings the landscape of Toledo, as earlier in Italy he had introduced the portraits of the great painters of Venice and Rome. The view of Toledo first appears in the *Saint Joseph and the Christ Child* (plate 26), painted in 1597, the year which marks the beginning of a whole series of important commissions which keep him occupied until his death in 1614. In this painting, whose theme is that of Man cherishing the spiritual meaning of the Universe and guided by it in his path through the World, the spiritual view of Toledo seems to symbolise the World. The Metropolitan Museum painting (plate 29) was probably conceived in connection with the same commission, for the view is the same, and the result was one of the most remarkable independent landscapes ever painted. The town appears subsequently in a number of paintings, where its presence is appropriate: in the *Christ on the Cross leaving this World* (plate 34); and in the late *Immaculate Conception* (plate 44), where it is little more than a vision. Significantly, in the *Saint John the Baptist in the Wilderness* (plate 36), the setting is the austere landscape of the Escorial. Although he had visited the Escorial in his first years in Spain, the studies for this landscape, like those of Toledo, were almost certainly made around 1596, when he visited Madrid in connection with the commission for the Colegio de Doña María. While the views keep close to the actual features of the landscapes, they are given a completely spiritual interpretation. The same thing occurs in his portraits.

The years 1600 to 1610 witnessed the full development of his powers as a portrait painter (plates 32, 35 and 43, figure 5). His personal style of portrait painting begins with the *Burial of the Count of Orgaz*, and closes with his great masterpiece, the portrait of his friend *Paravicino* (plate 43), painted in 1609 or 1610. Essentially related to the development of his portrait art was his great exercise in interpreting

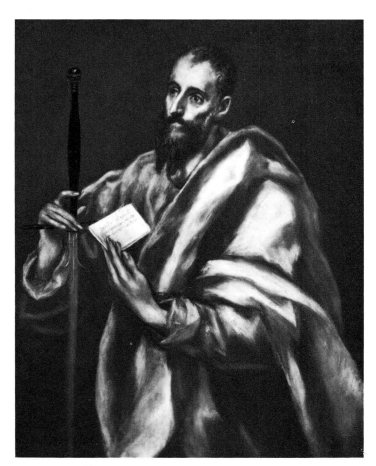

6 *Saint Paul.* (holding an Epistle addressed to Titus, first Bishop of the Cretans). c. 1610. Oil on canvas. 38 × 30½ in. (96 × 77 cm.). Signed. Museo del Greco, Toledo.

the characters of the Saints. In both he sought to express the reality of the spiritual personality.

'I have applied observations made of celestial bodies...' (El Greco, inscription on his *View and Plan of Toledo, c.* 1610.)
Toward the end of his life, the supernatural takes over. The late *Immaculate Conception* (plate 44) is not so much an expression of the mystery as its realisation in painting. A parallel expression is found only in the mystic poets of his time:
'On a Night dark and unfathomable, as anguish was consumed in flames of Love... I left my house, tranquil and calm, unseen and I not seeing, without any guide but the light that burned in my heart,... more resplendent than the Noon....'
In his 'Songs of the Soul', Saint John of the Cross, El Greco's almost exact contemporary, expresses the same infinity of spiritual space, in which an all-resplendent light and an infinite darkness are compatibles.
The towering, rock-like form of *Saint Peter* (plate 46), and the ecstatic *Visitation* (plate 45), with its strange impression of the 'coming together of two celestial bodies in space' (Camón-Aznar, *Dominico Greco,* 1950), belong to the same commission as the *Immaculate Conception.* His *Penitent Saint Jerome* (plate 47) is a purely spiritual presence, whose material being is dissolved in the impassioned handling. The tremendous vision of *Saint John* (plate 48) belongs to his last unfinished commission for the Hospital de San Juan Bautista, Toledo, and this vision of the Apocalypse fitly closes his career.

'Michelangelo was a good man, but he could not paint...' (Pacheco 'Arte de la Pintura', referring to the year 1611.)
It was in 1611 that Pacheco visited El Greco in Toledo. The erudite Sevillian painter was collecting material for his 'Book of Portraits' of eminent men and his 'Art of Painting', and made the journey to meet the great painter of Toledo whose fame had reached Seville. The Sevillian gives an honest and discerning report, in which admiration and understanding are mixed with a certain perplexity. It is the only contemporary account of El Greco's personality, ideas and methods of painting – apart from the eulogies of Góngora and Paravicino. Pacheco's learned theories, if not his

real sympathies, sought to uphold the primacy of Italian Renaissance painting, whose one exemplar was Michelangelo. He asks El Greco his opinion of Michelangelo as a painter, and El Greco shrewdly replies that he was not a painter, but that he was 'a good man'. This was one 'discerning remark' not appreciated by Pacheco, who was however not too surprised, for Domenicos was 'singular in everything'. There is, indeed, a truth in El Greco's reply: Michelangelo was essentially the great sculptor of the century, concerned with the human figure, form and drawing; El Greco was the great painter of the century, concerned with colour, whose art had less in common with that of the great Italian master than with that of the great contemporary poets and mystics, Paravicino and Góngora, Saint John of the Cross and Saint Teresa of Jesus. There is, however, a remarkable consonance between the late endeavours of Michelangelo as a sculptor and El Greco as a painter, each of whom exploited to the limits the expressive possibilities of their respective materials – form and colour.
Pacheco watched El Greco paint, and describes for us his 'open' and flexible technique; his diligence in making small-scale preparatory paintings; how he began with painting the design in red or black chiaroscuro – not a drawing, but the first broad statement of the design and movement in tone. The more general and 'certain' course was to make a precise delineation of the forms, and then to 'fill in' with the 'final colours'. El Greco's method included no drawing or filling in, but was essentially the heightening of the first broad preliminary painting by superimposing passages and touches of colours, until he had given a final variety and effectiveness to the colours, and vitality to the design. It was the last essential touches, those 'sketchy brushstrokes made to affect dexterity', that Pacheco was unable to understand. His infinitely flexible technique, including the use of superimposed glazes of colour as well as touches of pure paint, sought to give that living quality to his paintings, observed by Góngora who aptly summarises it in a sentence: 'His brush gave life and soul to the canvas.'

'His rare distinction, Ages will admire, not imitate...' (Paravicino, sonnet dedicated to El Greco, 1614.)
Like all great independent geniuses, El Greco could have

no real followers. His son was no more than a superficial imitator, who could not appreciate the essential inspiration that informed his painting. He was the one outstanding painter of his age, and no painter has better expressed the spirit of a particular time and place. He was understood by only a few in his time, and soon after his death was more or less forgotten. It is true that Velasquez and Zurbaran, who began studying painting from about 1610, were able to find inspiration in the great Toledan's portrait and devotional art, and two hundred years later, Goya certainly paid homage to the master when he painted his *Taking of Christ* to hang next to the *Espolio* in the Sacristy of Toledo Cathedral. Delacroix the great colourist, owned one of his paintings. To the exponents of naturalism and Impressionism El Greco's art could mean little. Cézanne's copying of the portrait of Jerónima de las Cuevas appears appropriately as a herald of the recognition that was soon to follow. The first real appraisal was Cossio's work published in 1908. It is El Greco's independence and artistic integrity, and the essential freedom and painterly quality of his work that have appealed to the present century.

The resurrection of his painting in our times has encouraged attempts to make up a biography of the man. The very absence of records has encouraged a belief in his exotic character, and has allowed various misinformed explanations of his art. It is no longer necessary to consider defective vision, mental aberration or drug addiction as explanations for his painting. We know him no better by seeking intriguing interpretations of his relationship with Doña Jerónima. The fact is, we know practically nothing about the man; time has preserved for us only the splendid revelations of one of the greatest and most individual masters of colour.

Biographical outline

1540/1541 Domenicos Theotocopoulos born in Candia, Crete in 1541 or the end of 1540. The only evidence for the date of birth is the artist's own statement, made on 31st October and again on 4th November, 1606, that he was sixty-five years of age. On two occasions, the town of Candia is specified: in Giulio Clovio's letter of 1570 and in 1582, when the artist was acting as interpreter in the trial of another 'Greek' in Toledo, when he states he was a native of the 'town of Candia'. On all other occasions, he is referred to simply as Cretan.

1560s In Venice as a pupil of Titian. Clovio's letter of 1570 is the only evidence.

End 1570 Moves from Venice to Rome. The evidence is a letter dated 16th November 1570, from Giulio Clovio in Rome addressed to Cardinal Farnese, asking the Cardinal to place the 'young Candian, a pupil of Titian's, recently arrived in Rome', under his protection and give him temporary lodging in his palace. Clovio introduces the young artist as 'in my opinion among the greatest in painting' and mentions a *Self-portrait* (lost) which 'causes wonderment among all the painters of Rome'.

1576-1577 At the end of 1576 or early in 1577, moves to Toledo, in Spain, where he finally settles.

1577 By the spring of 1577, in Toledo, to carry out the commission for Santo Domingo el Antiguo. El Greco was to paint 'all by his own hand and in Toledo'. He was also responsible for designing the retable of the main chapel with its sculptures (the Escorial artist J.B. Monegro was commissioned to carve the retable 'after the plans of Mecer Domenico Theotocopuli'). Almost all subsequent large commissions include the designing of the retables or frames for his paintings, and in some cases the sculptures. Soon after arrival in Toledo, receives the further commission to paint the *Espolio* for the Cathedral. He had received both commissions before 2nd July 1577, the date of the earliest document establishing his presence in Toledo and Spain.

1578 Birth of a son, Jorge Manuel, to El Greco and Jerónima de las Cuevas. El Greco apparently never married.

1579 Completion of the works for Santo Domingo and the Cathedral. The *Espolio* was completed by 15th June, the date of the first valuation, and the Santo Domingo works by September. The *Espolio* valuation led to the first of a series of litigations which became a feature of almost all El Greco's important commissions. The Cathedral's valuation of roughly 225 *ducados* was answered by El Greco's of 900 *ducados*, which the Cathedral authorities considered 'beyond all reason'. An arbitrator finally valued the work at roughly 320 *ducados*, but with the observation that it was 'of the best he had ever seen' and that 'if one should value it at its true worth, it would be in a sum that few or none would be prepared to pay'- the outstanding quality of El Greco's work is acknowledged for the first time. In this litigation, the Cathedral authorities also chose to censure the artist's treatment of the subject, and stipulated that certain improprieties should be made good, 'that take authority from Christ, as the three or four heads above that of Christ, two of them with helmets; and also the Maries and our Lady are against the Gospels, for they were not in this place'. El Greco made no changes to the picture. Apparently fearful that the artist might leave Toledo with the painting, it was complained that 'he had the painting, for which he had already been paid 200 *ducados*; he was a foreigner with no property in Toledo, and had finished the work for which he came to Toledo, that is, the Santo

Domingo retable, and no longer had any reason to remain.'

1579-1580 Philip II commissions the *Martyrdom of Saint Maurice and his Legions* for one of the chapels of the church of the Escorial. On 25th April 1580, the King orders the Prior of the Escorial to provide El Greco with materials, 'especially ultramarine', to enable him to carry out the commission 'made some time ago'. The painting, executed in Toledo, completed 1582. El Greco paid 800 *ducados*. The painting did not satisfy the King: 'by a Dominico Greco... who paints excellent things in Toledo, is a painting of Saint Maurice and his soldiers, which he made for the altar of the Saints, and is now in the Chapter House; it did not please His Majesty, but that is not surprising, for it pleased few, although it is said it is of much art and that there are many excellent things by his hand'. (Padre Sigüenza, *Historia de la Orden de San Jerónimo*, 1608).

1585 The Dean of Toledo Cathedral commissions the retable for the *Espolio* (the retable is lost, but the carved and painted group from the retable, of the *Virgin presenting the Chasuble to Saint Idelfonso*, is still in the Cathedral).

1586 Painted the *Burial of the Count of Orgaz*. Commissioned March 1586, to be completed by Christmas of the same year. El Greco received 1200 *ducados*. A certain popular acclaim is immediately earned: 'foreigners flock to see and admire the painting, and the citizens of Toledo never tire of seeing it, as there is always something new to see, for here is portrayed, very life-like, the notable men of our time' (Alonso de Villegas, *Flos Sanctorum*, 1578). The portraits include those of himself and his son.

1591 Commission for the paintings of the high altar of the church of Talavera la Vieja, Cáceres province. The paintings were: the *Coronation of the Virgin*,

the model for his later versions of the same subject for the church of San José, Toledo, and the Hospital de la Caridad, Illescas; and the two full-length standing Saints, Peter and Andrew. He received 300 *ducados* for the work, which must have been largely executed by assistants.

December 1596 Commission by the Royal Council of Castile for the retable and paintings for the high altar of the Church of the Augustine College of Doña María de Aragón, Madrid, dedicated to Our Lady of the Annunciation. The College was a foundation of Doña María's, lady-in-waiting to Philip II's fourth wife (d. 1593). The paintings were executed in Toledo, and delivered July 1600; El Greco receiving nearly 6000 *ducados* for the paintings, designs for the retable, and sculptures for this large commission for the Court.

1597 November 1597, commission for the retables of the Chapel of San José, Toledo, completed two years later. El Greco received 2850 *ducados*.

1603 Contract for the *Saint Bernardino*. Paid 300 *ducados*. Contract for the Hospital de la Caridad, Illescas (between Toledo and Madrid), dated 18th June 1603. The commission given to 'Domingo Greco and Xorje Manuel, painters' (the son could hardly have been more than an assistant). The commission apparently included the decoration of the whole chapel, including the design for the retable and the provision of sculptures as well as paintings. The paintings comprised the *Virgin of Charity* and three paintings for the vault, the *Coronation of the Virgin* and the *Annunciation* and *Nativity*. The work was completed by August 1605, the date of the first valuation, which led to lengthy litigation, only finally settled in May 1607, at little more than 2000 *ducados*, actually less than the first. This time El Greco was not only censured on account of certain improprieties, but also for the poor workmanship and materials (successfully

disproved). The 'improprieties' referred to the inclusion of the portraits of Jorge Manuel and other known people wearing large ruffs, and the general arrangement of the chapel, and placing of the sculptures. On El Greco's side, it was maintained that the chapel was 'the best, and in its construction, of the greatest perfection in Spain', that 'it was remarkable that the dress that all Christianity wears should be regarded as indecent' and that 'it should not be changed as otherwise they would appear as Saints instead of men'. It is not known whether El Greco ever painted over the portraits and replaced them by 'decent' figures, but it is hardly likely. At some time, however, they were overpainted, but El Greco's original figures have been recently uncovered. At one stage, the Hospital authorities threatened they would get a painter from Madrid to paint the Virgin of Charity 'properly'.

1603-1607 In these years, Luis Tristán is recorded as a pupil of El Greco's (the only pupil of any standing).

1606 In connection with the Illescas commission, El Greco successfully contests payment of tax, arguing that he practised painting as a liberal art. This is the first occasion in Spain of official recognition of painting as a liberal, and not mechanical, art.

1607 November 1607, contract for the decoration of the Chapel of Isabel de Oballe in the Church of San Vicente, Toledo. The paintings comprised the *Immaculate Conception*, the *Visitation* for the vault, and the *Saint Peter* and *Saint Ildefonso* for the side altars. The contract stipulated that the retable was to be higher than the one designed by Semino (who had died shortly after receiving the commission), for 'to be a dwarf was the worst condition of man' – surely El Greco's comment. The work was not finally completed until April 1613, the year before his death.

1608 Commissioned paintings for the church of the Hospital of San Juan Bautista (Hospital Tavera), Toledo, including the *Baptism*, finished by Jorge Manuel after his death, and the *Vision of the Apocalypse*. El Greco had been connected with the Hospital from 1595, when he received a commission for the design of a tabernacle. The Hospital, outside the walls of the town, appears on a cloud in his *View and Plan of Toledo* (not shown), in the Museo del Greco, Toledo, possibly painted about this time. An inscription, composed by El Greco, on the plan of Toledo in this painting reads:

'It has been necessary to show the Hospital de Tavera as a model, for the building hides the Visagra Gate, and the dome obscures part of the town, and once treated as a model and moved from its place, it seemed better to me to show the main façade ... the rest, and its proper relationship to the town can be seen on the plan. Also, in the representation of Our Lady presenting the Chasuble to Saint Ildefonso, in making the figures large, I have applied, in some way, the observation made of celestial bodies that an illuminated body seen at a distance may appear large although it be small'.

1609-1610 Portrait of *Paravicino*.

1611 Visited by Pacheco. Designed a monument for the funerary celebrations in Toledo Cathedral in honour of Margarita of Austria, widow of Philip II, who had died in that year.

1612 The artist rents a family burial vault in the church of Santo Domingo el Antiguo, Toledo, the church for which he painted his first works in Spain, on condition that he builds the altar and retable at his cost. For the retable he painted the *Adoration of the Shepherds* (plate 49), now in the Prado.

31st March 1614 El Greco 'confined to his bed', 'holding, believing and confessing the Faith of the Holy Church of Rome ... in whose Faith I have lived and die,

as a faithful and Catholic Christian ... because of the gravity of my sickness I was unable to make a will', gives power to Jorge Manuel Teotocopuli 'my son and of Doña Jerónima de las Cuevas, who is a person of honesty and virtue', to make his testament, arrange his burial, and pay his debts, and the 'remainder of my possessions to go to Jorge Manuel, as universal heir ...'.

7th April 1614 El Greco dies. — 'dominico greco, On the seventh (of April) dominico greco died, made no will. Received the sacraments, was buried in Sto domingo el antiguo, gave mass' (entry in Book of Burials of the parish of Santo Tomé, Toledo).

7th July 1614 The inventory of El Greco's possessions made by his son included the following items in his studio: 143 paintings, mostly finished, some painted as far as the chiaroscuro design, and some 'unfinished'; 30 models in clay and wax, 15 in plaster; 27 books in Greek including the philosophers and poets, Old and New Testaments, and the Fathers of the Church; 67 books in Italian, and 17 in Spanish. 120 drawings (probably the larger part his own, but unfortunately only three or four certain drawings have come down to us); 30 plans (probably for retables); and 200 engravings (a collection of engravings for reference and study was part of any artist's studio).

FURTHER DATES RELATING TO EL GRECO'S CAREER

1563 Building of El Escorial commenced.

1564 Death of Michelangelo in Rome.

1571 Victory of Lepanto.

1576 Death of Titian in Venice.

1579 The body of Don Juan de Austria (d. 1578), victor of Lepanto, translated to the Pantheon of the Escorial.

1579 Death of the Spanish painter Navarrete, leaving unfinished the greater part of the commission to provide paintings for the thirty-six chapels of the church of the Escorial.

1582 Death of Saint Teresa of Jesus.

1584 Death of the Spanish painter, Luis de Morales, 'el Divino'.

1591 Death of Saint John of the Cross.

1598 Death of Philip II.

1599 Birtn of Velasquez.

PACHECO ON EL GRECO

The few passages in Pacheco's 'Arte de la Pintura' contain the only comments on the man and his painting made by a contemporary acquaintance, with the exception of the eulogies of Paravicino and Góngora, and the text is given in full: 'The most important part of painting is "relief", and there are many great painters who have possessed this quality alone, as Bassano, Caravaggio and our Ribera, and we may also include Domenico Greco, for although I have disagreed with certain of his opinions and paradoxes, it is not possible to exclude him from the number of great painters, for I have

seen some works by him of such "relief" and so alive – in his particular manner – that they rank with the greatest.' (Book 2, chapter 10).

'Among the exponents of this manner (referring to the Venetian "open" technique) there have been great painters, including especially Bassano, whose sketches are superior to many finished works by others: and in Spain there has been one who has endeavoured to give distinction to an individual kind of "sketch", not practised before and not followed since.' (Book 2, chapter 11, Sánchez Cantón properly considers this to be a reference to El Greco).

Pacheco refers to the various ways of carrying out a painting after the initial drawing has been made on the canvas: 'Some start their painting by using only black and white . . . or red and white' (that is, monochrome under-painting) '. . . some paint directly using the final colours . . . the advantage of oil is that one can retouch . . . as Titian. Some when they have finished the underpainting, complete the work by adding final rapid strokes ('borrones') intending thereby to demonstrate greater facility and dexterity than others. And who would believe that Domenico Greco retouched his paintings many times in order to keep the colours separate and distinct, and added those violent brushstrokes to affect mastery . . . this I call working to be poor.'

Pacheco continues by recommending that the flesh parts be painted first, and that finally one should go over the painting and give it 'finish'. It is understandable that he was a little perplexed by El Greco's completely different method of painting (Book 3, chapter 5).

'In our time, there have been painters learned not only in their profession but also in the humanities, as Michelangelo, also a poet; Leonardo da Vinci . . . ; Vasari; and Domenico Greco, who was a great philosopher, shrewd in his remarks, and wrote on painting, sculpture and architecture' (Book 3, chapter 9).

'This honour (of being the great painter of Saint Francis) belongs to El Greco, for he conformed most closely to the story' (additions, concerning the proper treatment of religious subjects).

Pacheco discussed the importance of drawing: 'I was thus amazed on asking El Greco in 1611 which was the more important, drawing or colouring, that he should say colouring, but this was not so surprising as to hear him speak with so little respect of Michelangelo, "the Father of Painting", saying that he was a good man but that he did not know how to paint. It will not, however, surprise those who know him, that the sould depart from the generally held opinion, for in everything, as in painting, he was singular' (Book 2, chapter 5).

Pacheco refers to El Greco's individual opinion, in opposition to that of Aristotle and of the antique authors, that the painter does not necessarily have to follow certain prescribed rules (Book 12, chapter 12).

GONGORA AND PARAVICINO ON EL GRECO

This hard stone, of shining porphyry and elegant form, denies 'to the world the softest brush ever to give soul to panel, life to canvas. Oh traveller! Honour it, and go on your way! Here lies the Greek. Nature inherits Art; . . .; Iris, Colour; Phoebus, Light; though Morpheus his shades are not augmented . . .'. (Góngora, Sonnet, 'A funeral lament to El Greco', 1614.)

'Of El Greco that which can be confined lies at rest . . . His fame, Earth will not suffer obscure, yet Envy seeks . . . He worked, a greater Apelles in a greater Age; applause was his, not sought; his rare distinction Ages will admire, not imitate. Crete gave him his life, and brushes; Toledo, a better land, where he begins with Death to attain, Eternity.' (Paravicino, Sonnet, 'A funeral lament to El Greco, 1614).

Notes on the plates

Plate 1 *Mount Sinai.* 1560–65. Tempera on panel. 14½ × 9⅜ in. (37 × 23 cm.). Signed. Galleria Estense, Modena.

The back of the central panel of the 'Modena Triptych', (a small portable altarpiece with hinged wings) painted on both sides. This is of a type similar to others produced in Crete in the sixteenth century. The subjects on the front are: the *Allegory of a Christian Knight* (on the central panel), the *Adoration of the Shepherds* and the *Baptism* (Plate 2); and on the back, the present picture, flanked by the *Annunciation* and *Adam and Eve*. The theme of Mount Sinai was of Cretan origin, and faithfully repeats a traditional Byzantine pattern. The picture shows pilgrims on the way to the Monastery of Saint Catherine, and the Mountain as the Road to Heaven. The *Allegory of a Christian Knight*, showing the Christian Knight received into Heaven, with Purgatory and Inferno below, and the three Theological Virtues, is of medieval inspiration, and precisely follows a known representation of the subject. The Jaws of Hell are a specifically medieval motif. The presence of Saint Catherine in this painting and the reference to the Monastery of Saint Catherine on the *Mount Sinai* panel indicate a Cretan origin and the possibility of the artist's connection with the Monastery of Saint Catherine in Crete, a dependency of that of Mount Sinai and the most important school of painting at the time in Crete. The paintings of the Modena triptych introduce us to the Cretan artist soon after his arrival in Italy. We see the artist acquainting himself with the new Italian subject matter and making his first essays in the new technique of Venice. None of the compositions is, apparently, original, and for those of the wings, engravings after Italian (mainly Venetian) compositions have been employed as models. The flat, linear, geometrical designs of Byzantine art give way to compositions employing rounder, more solid forms, and a looser handling. The 'Master Domenicos' of the signature has recently been questioned as a reference to Domenicos Theotocopoulos. His manner soon after his arrival in Venice would be little distinguishable from that of a number of Cretan artists working in the city. The Modena Triptych contains motifs and compositions that El Greco was later to develop. The *Allegory of the Christian Knight* is recollected in the *Allegory of the Holy League* (plate 13), and the Byzantine image of *Mount Sinai* is not unreasonably brought to mind in front of the late view of *Toledo* (plate 29).

Plate 2 *The Baptism of Christ.* Tempera on panel. 1560–65. 9⅝ × 7 in. (24.5 × 18 cm.). Galleria Estense, Modena.

Painted on the front of the right wing of the 'Modena Triptych' (see preceding note). The plate approximately reproduces the actual size of the painting.

Plate 3 *Christ Healing the Blind.* c. 1570. Oil on canvas. 19¾ × 24 in. (50 × 61 cm.). Signed. Pinacoteca Stuard, Parma.

Possibly the sequel to the *Christ driving the Traders from the Temple* (Matthew, XXI, 14: 'And the blind and the lame came to him in the temple; and he healed them'). Both subjects were treated by El Greco more than once in Italy. This is the smallest known painting on canvas by El Greco. The painting has been cut and the group on the right is incomplete. No large-scale works are known from his Italian period, and most are quite small. He does not appear to have received any important commissions before he moved to Spain. Three versions of this subject are known, all basically the same in composition, but differing in treatment. The earliest, an unsigned panel in Dresden, is looser in composition, smaller in conception, and introduces *genre* motifs of a dog, sack and pitcher in the foreground, eliminated in subsequent versions. The present painting, probably also painted in Venice, is more easily composed. The third and largest painting, now in a private collection in New York (possibly identical with the one in a Madrid collection at the time of Cossío's pioneer work on El Greco), with its comparative largeness of conception, belongs to his Roman period, after 1570. El Greco did not again take up the subject in Spain. The inspiration is from Venice. The dramatic use of recession behind the figures in the foreground is Tintoretto's invention. El Greco is still borrowing certain motifs, but the composition would seem to be original. The painting was among the Farnese possessions in the seventeenth century, and was probably brought to Rome by the artist, unless it was painted soon after his arrival in 1570. The figure on the extreme left, looking out towards the spectator, is certainly the young El Greco, but he appears nearer twenty than thirty years old.

Plate 4 *Portrait of Giulio Clovio.* c. 1571. Oil on canvas. 25 × 34½ in. (63 × 88.5 cm.). Signed. Museo Nazionale

di Capodimonte, Naples.

Giulio Clovio (1498–1578), a 'Greek' from Croatia, friend of El Greco's, worked as a miniaturist in the Farnese Library. He is portrayed holding an open book (the *Libro della Vergine*, at the time in the Farnese Library, and now in the National Museum, Naples) displaying two of his own miniatures. The portrait was painted probably soon after El Greco arrived in Rome (November 1570), and almost certainly for his friend. In the seventeenth century, it was in the possession of Fulvio Orsini, librarian to Cardinal Farnese. This is perhaps the earliest independent portrait by the artist who was to become one of the greatest portrait painters of all time. Three splendid portraits belong to his Italian years: the present portrait, possibly the earliest, and the signed portrait of a man in Copenhagen, both Titianesque; and the more personal *Vincentio Anastagi* (plate 7). It is unfortunate that the self-portrait mentioned by Giulio Clovio is lost.

Plate 5 *Christ Driving the Traders from the Temple* (The Cleansing of the Temple) 1571–76. Oil on canvas. 46 × 59 in. (117 × 150 cm.). Signed. Institute of Arts, Minneapolis.

(Matthew, XXI, 12; the sequel is possibly the *Christ Healing the Blind*.) The four portraits at the bottom right represent, from left to right, Titian, Michelangelo, Giulio Clovio and possibly El Greco himself (detail, figure 2). The introduction of Titian and Michelangelo clearly acknowledges his debt to these two artists. To his friend, Giulio Clovio, he owed his introduction to the Farnese household. The young man looking out, pointing to himself, has similar features to the self-portrait in the *Christ Healing the Blind* at Parma (plate 3), but the long hair is strange. It has also been suggested that he could represent the young Raphael. The portraits of Titian and Michelangelo (died 1564) were taken from existing portraits, and that of Giulio Clovio follows closely El Greco's portrait of his friend in the Naples Museum (plate 4), painted c. 1571. El Greco does continue to include portraits in his paintings of religious subjects, but here there is no proper connection with the subject matter. El Greco first painted the subject in Venice, some years earlier, in the small signed panel in Washington, and he was to take it up again, much later, in Spain, and adhere closely to his original design (plate 31). As with the *Christ Healing the Blind*, inspiration for

the composition as a whole is from Tintoretto. The main central group, however, is very close to a Michelangelo design, known in drawings, and also in Venusti's painting after Michelangelo's design (National Gallery, London). The figure of the woman, walking with a child, could be a reminiscence of a similar motif in Raphael's tapestry cartoon, *The Distributing of Alms at the Golden Gate*. The two men in conversation, who also appear in the middle distance of *Christ Healing the Blind*, have become a grand subsidiary motif, and again hint at acquaintance with Raphael. The larger forms of the architecture also derive from Raphael and Rome, and are consonant with the grander conception of the one integrated action of the main group of figures.

Plate 6 *The Pietà* (The Lamentation of Christ). 1571–76. Tempera on panel. 11½ × 8 in. (29 × 20 cm.). Signed. John G. Johnson Collection, Philadelphia.

A translation in paint of Michelangelo's late sculptured group of the *Pietà* in Florence Cathedral, at the time in Rome. The pattern and the feeling are the same. The figures of the Dead Christ, His Mother, Saint Mary Magdalene and Joseph of Arimathea make one compact group. Michelangelo achieved this by his new treatment of form; El Greco by paint, by employing broader, more continuous passages of colour. The more vivid colours of Rome combine with the richer palette of Venice to convey the intensity of expression demanded by the subject. The horizontal composition of Venice, more suited to a narrative type of subject than to the single image, is given up and is only very rarely found appropriate in Spain. In the collection of the Hispanic Society of America is a larger version of the subject, unsigned, in oil on canvas, for which this may be a study.

Plate 7 *Portrait of Vincentio Anastagi*. c. 1576. Oil on canvas. 74 × 50 in. (185 × 125 cm.). Signed. The Frick Collection, New York.

An inscription, added possibly in the seventeenth century and recently removed, gave the information that the sitter was a Knight of Malta (a later addition of the Maltese Cross painted on his chest was also removed during recent cleaning) and a Governor of the City, who had assisted in the defence of the City besieged by the Turks, and died in Malta in 1586.

If painted in Malta, it could have been done when the artist was *en route* to Spain. In any event, it represents his style shortly before he left Italy for Spain. The individual treatment of the portrait, with the striking effect of the silhouette and colouring, distinct from that of the portrait of *Clovio* (plate 4), which so clearly betrays its Venetian inspiration, presages the personal development of his art in Spain.

Plates 8, 9 Paintings for the High Altar and side altars of the Church of Santo Domingo el Antiguo, Toledo, begun in the spring of 1577 and completed in the summer of 1579.

Plate 8 *The Assumption of the Virgin*. Signed and dated 1577. Oil on canvas. 158 × 90 in. (401 × 229 cm.). Art Institute of Chicago. Gift of Nancy Atwood Sprague in memory of Albert Arnold Sprague.

Painted for the central panel of the High Altarpiece of the church of Santo Domingo el Antiguo, Toledo, the commission which brought him to Spain. This, the first work executed in Spain, is the only painting by El Greco bearing the date of its execution. It is the first large-scale painting by his hand. There is a clear reminiscence of Venetian paintings of the subject, and specifically of Titian's early masterpiece in the church of the Frari in Venice, but the treatment is his own. The Virgin rises as from a chalice formed by the two unified groups on either side of the open tomb, which introduce and extend motifs developed in his *Cleansing of the Temple* and *Healing of the Blind*. A complete unity is achieved in this bi-partite composition, in which the circle of Apostles, with its contained and concentrated internal movement, or emotion, is continued in the circle of angels with their easy and sympathetic movement around the rising figure of the Virgin. There is a sustained rhythm of expressions, gestures and surface treatment within each group, and an easy, inevitable connection between them. This is achieved essentially by paint, the measured relationship of the passages of colour over the surface. This also explains his treatment of the draperies, which has its own logic, has no suggestion of conflict, but is also not concerned with disclosing the anatomy beneath. No other version of the subject is known, but the painting may be regarded as the forerunner of the related composition of the *Immaculate Conception*, a subject more compatible with El Greco's mystical approach to the Universe.

Plate 9 *The Trinity*. 1577–79. Oil on canvas. 118 × 70½ in. (300 × 179 cm.). Not signed. Museo Nacional del Prado, Madrid.

Painted for the attic of the high altarpiece of Santo Domingo el Antiguo, Toledo, to go above the *Assumption* (plate 8). Probably painted 1577–78, following the *Assumption*. Here the reference is to Rome, rather than to Venice, and specifically to Michelangelo, developing the motif of the *Pietà* (plate 6). The general scheme of the composition of the *Trinity*, however, refers to Dürer's engraving of the same subject. The composition continues that of the *Assumption* below, slowing down the upward movement which finally comes to rest in the supported shoulders of Christ. Form is more in evidence here than in the *Assumption*, especially in the Michelangelesque motif of the naked Christ. Only later does he treat his figures with the same freedom as the draperies. Here the suggestion of weight in the supported Dead Christ is appropriate. El Greco was not to repeat this subject.

Plate 10 *The 'Espolio'* (Disrobing of Christ). Oil on canvas. 112 × 68 in. (285 × 173 cm.). Signed. 1577–79. Sacristy, Toledo Cathedral.

Commenced in the summer of 1577, and completed in the spring of 1579, for the High Altar of the Sacristy of the Cathedral, where it still hangs. A document of 2nd July 1577 referring to this painting is the earliest record of El Greco in Spain. El Greco has produced one of the most dignified and moving portrayals of Christ in art. The powerful effect of the painting especially depends upon his original and forceful use of colour. Something of the effect of the grand images of the Saviour in Byzantine art is recalled. The motif of the crowding round Christ suggests an acquaintance with the works of the Northern artist, Bosch; the figure preparing the Cross could be derived from the similar figure bending forward in Raphael's tapestry cartoon of the *Miraculous Draught of Fishes*. This is, however, the last time that there are any hints of specific borrowings. A small, signed version of the *Espolio*, at Upton Park, Warwickshire, is probably the original preliminary model for the large painting. Many other versions exist, but few can be by El Greco.

The only occasion that he treated the subject was for the Cathedral, but the type of Christ created in the *Espolio* is taken up in the related subject of *Christ carrying the Cross* (plate 33), and in other representations of Christ. The initial reception of the painting, when seen by the artists brought to value it, was that it was beyond appraisal. Two hundred years passed before it again received due recognition, when Goya painted his *Taking of Christ* for the same sacristy.

Plate 11 *Lady with a Fur* (Jerónima de las Cuevas?). 1577–80. Oil on canvas. 24½ × 20 in. (62 × 51 cm.). Not signed. Mrs Maxwell MacDonald, Pollok House, Glasgow.

Most likely a portrait of Jerónima de las Cuevas, his life-long companion in Spain, and the mother of his son, Jorge Manuel. The style belongs to his first years in Spain. The treatment, with the greater continuity of brushstroke, is related to that of his portrait of *Vincentio Anastagi* of his last years in Italy, and to his first paintings in Spain. The fact that he painted very few female portraits, the intimate quality of the portrait, the apparent age of the sitter, and the correspondence in time with the setting up of his household, all point to the identification as Doña Jerónima. Cézanne's copy of the painting (1879–80; Pellerin collection, Paris) heralded the ultimate recognition of the artist.

Plate 12 *Saint Mary Magdalene.* 1580–85. Oil on canvas. 42¾ × 34¼ in. (108 × 87 cm.). Not signed. Nelson Gallery, Kansas City, Atkins Museum, Nelson Fund.

The Penitent Magdalene is one of the most recurrent themes. She and Saint Veronica, both close to Christ and His Passion, are the only female Saints he treated. A comparison with the *Saint Sebastian* indicates a somewhat later dating. An earlier version, signed, of identical pose, is in the Art Museum, Worcester, U.S.A.; and one of the final representations is the ecstatic Magdalene in the Valdés Collection, Bilbao. The painting is based on a Titian type, although there is no record that he portrayed the Saint before he moved to Spain.

Plate 13 *The Adoration of the Name of Jesus* ('Dream of Philip II'). 1578–79. Oil on panel. 22¾ × 13¾ in. (58 × 35 cm.). Signed. National Gallery, London.

A study for the large painting in the Chapter House of the Monastery of El Escorial, painted probably by 1579. The earliest reference to the painting in the Escorial appears in Francisco de los Santos, *Descripción . . . del Escorial*, published in 1657, when it was in the sacristy of the Pantheon: '. . . commonly called the "Glory of El Greco" on account of the Glory above; but there is also represented, below, Purgatory and Hell, and on the other side, the Church Militant, with an immense number of the Faithful in adoration, raising their hands and eyes to Heaven, and among them Philip II; in the middle of the Glory is the Name of Jesus adored by Angels . . . signifying the words of Saint Paul *In Nomine Jesu omne genu flectatur Caelestium, Terrestrium, & Infernorum* (Saint Paul. Epistle to the Philippians, II, 10)'. The subject, then, is the Adoration of the Name of Jesus, a Jesuit counterpart of the Adoration of the Lamb, and incorporates the 'Church Militant', represented by the Holy League. The popular title, the 'Dream of Philip II', is more recent. The painting must certainly have been made for Philip II, but no documents refer to it, and it is strangely not mentioned by Sigüenza in his description of the Escorial, published in 1608. The occasion of the commission may well have been the death of Juan of Austria in 1577, and the translation of his body to the Pantheon of the Escorial in 1578. The painting was in the Pantheon when de los Santos described it. Juan of Austria was the General in charge of the forces of the Holy League at the Victory of Lepanto in 1571. The three members of the Holy League, Spain, Venice and the Papal States, are represented by the three kneeling figures of Philip II, Doge Mocenigo and Pope Pius V; and the one prominent figure of the foreground group, kneeling in heroic pose, and holding a sword, can represent no other than the General in charge at Lepanto. It is an ideal representation, whilst the King, Doge and Pope are actual portraits. Sir Anthony Blunt first suggested that this *Adoration of the Name of Jesus* was an allegory of the Holy League (the 'Church Militant'), and was possibly commissioned for the tomb of the Spanish General in the Pantheon. That is, it was more in the nature of a private commission for the King, and not part of the scheme of decoration of the Escorial. This could explain the absence of documents. The spirit of universal adoration is brilliantly conveyed. For the general arrange-

ment of the painting, El Greco appropriately referred to his *Allegory of a Christian Knight,* of the Modena Triptych (see note to plate 1). The figures of the King, Doge, Pope and Juan of Austria take the place of the three Theological Virtues; the Jaws of Hell and the representation of Purgatory are very closely followed. The heroic figure of Juan of Austria is inspired by Michelangelo. So special a commission could hardly have been the subject of a test-piece for the Escorial as has generally been suggested. The *Martyrdom of Saint Maurice and his Legions* (plate 14) was a specific commission (and the only commission) for the Escorial. The Escorial painting follows the small study in the National Gallery very closely, the main distinction being its somewhat broader format, and the widening and more explicit rendering of the circle of figures on Earth, and correspondingly, of the circular opening of the Heavens above.

Plates 14, 15 *The Martyrdom of Saint Maurice and his Legions* (and detail). 1579/80–82. Oil on canvas. 176½ × 118½ in. (448 × 301 cm.). Signed. Chapter House, Monastery of El Escorial.

The signature appears on the paper held in the mouth of a serpent (the spirit of evil, or of the Earth). The large painting was commissioned by Philip II, late 1579 or early 1580, for the chapel of the Saint in the church of the Escorial. The earliest reference is the King's order to the Prior, dated 25th April 1580, to provide the artist with materials, 'especially ultramarine', to enable him to carry out the commission given some time ago. El Greco had clearly already decided upon the dominant colour for the painting. The painting was completed by 16th November 1582, when it was delivered to the Escorial. The commission was probably prompted by the death of Navarrete in 1579, who left unfulfilled the greater part of his commission to provide paintings for the thirty-six altars of the church. The painting did not satisfy the King, Cincinato was commissioned to paint a substitute for the chapel and El Greco received no further commissions from the King. The subject of the martyrdom of the soldier Saint with his legions, for his refusal to worship the pagan gods was appropriate for the Escorial, the real centre of the crusade for the Faith. This subject expresses the conviction of faith that inspired the crusade; the *Allegory of the Holy League* (plate 13), the militant spirit of the crusade itself. The ecstatic character of this 'invitation to death' (Ortega y Gasset) is expressed. The physical side of the martyrdom is not emphasised, is no more than symbolised by the small group on the left comprising the one martyred figure, the figure, in the pose of El Greco's Christ of the Baptism, awaiting martyrdom and the grand figure in back-view of the executioner. The impression of the ranks of the Saint's army awaiting martyrdom is similar to that of the multitude in adoration in the *Adoration of the Name of Jesus.* The two paintings are related in composition, and in their expression of devotional fervour. The grand group of Saint Maurice and his companions owes much to the heroic figure style of Rome. There is however no emphasis on weight or volume. There is also no emphasis on spatial depth. The detail illustrates El Greco's personal interpretation of Michelangelo's heroic figure style.

Plates 16, 17 *The Burial of the Count of Orgaz* (and detail). 1586. Oil on canvas. 179 × 141 in. (480 × 360 cm.). Signed. Church of Santo Tomé, Toledo.

The contract for the painting is dated 18th March 1586. El Greco agreed to finish the painting by Christmas of the same year. This commission again resulted in litigation over the valuation, the final outcome of which was that the artist accepted the amount of the original valuation, 1200 *ducados.* The painting illustrates a popular local legend. In 1312, a certain Don Gonzalo Ruíz, native of Toledo, and Señor of the town of Orgaz, died (the family received the title of Count, by which he is generally known, only later). He was a pious man who, among other charitable acts, left moneys for the enlargement and adornment of the church of Santo Tomé (El Greco's parish church). At his burial, Saint Stephen and Saint Augustine intervened to lay him to rest. The occasion for the commission of the painting for the chapel in which the Señor was buried, was the resumption of the tribute payable to the church by the town of Orgaz, which had been withheld for over two centuries. The painting remains in the chapel – the actual scene of the event – for which it was ordered. Already in 1588, people flocked to see the painting. This immediate popular reception depended, however, on the 'life-like portrayal

of the notable men of Toledo of the time'. Indeed, this painting is sufficient to rank El Greco among the few great portrait painters. Nowadays the painting can communicate to us a whole society and age, as perhaps no other single work of art can, and at the same time offer us one of the great marvels of painting. It was the custom for the eminent and noble men of the town to assist at the burial of the high-born, and it was stipulated in the contract that the scene should be represented in this way. Without the contemporary confirmation, it would be clear that all are portraits. Unfortunately, there is no record of the identity of the sitters. Andrés Núñez, the parish priest, and a friend of El Greco's, who was responsible for the commission, is certainly the figure on the extreme right. The artist himself can be recognised in the *caballero* third from the left, immediately above the head of Saint Stephen. The artist's son acts as the young page. The signature of the artist appears on the handkerchief in the pocket of the young boy, and by a strange conceit it is followed by the date '1578' – the year of Jorge Manuel's birth, and certainly not the date of the painting. The boy points to the body of the deceased, thus bringing together birth and death. The painting is very clearly divided into two zones, the heavenly above and the terrestrial below, but there is little feeling of duality. The upper and lower zones are brought together compositionally (e.g., by the standing figures, by their varied participation in the earthly and heavenly event, by the torches, cross, . . .). The grand circular mandorla-like pattern of the two Saints descended from Heaven echoes the pattern formed by the Virgin and Saint John the Baptist, and the action is given explicit expression. The point of equilibrium is the outstretched hand poised in the void between the two Saints, whence the mortal body descends, and the Soul, in the medieval form of a transparent and naked child, is taken up by the angel to be received in Heaven. The supernatural appearance of the Saints is enhanced by the splendour of colour and light of their gold vestments. The powerful cumulative emotion expressed by the group of participants is suffused and sustained through the composition by the splendour, variety and vitality of the colour and effects of light. This is the first completely personal work by the artist. There are no longer any references to Roman or Venetian formulas or motifs. He has succeeded in eliminating any description of space. There is no ground, no horizon, no sky and no perspective. Accordingly, there is no conflict, and a convincing expression of a super-natural space is achieved. This is the beginning of his real development, and the process of dematerialisation and spirit-ualisation continues. In the detail (plate 17), Saint Stephen (left) and Saint Augustine intervene in the laying to rest of the body of the Count of Orgaz in his chapel in the church of Santo Tomé, Toledo. The painting still hangs there. The artist's own portrait appears immediately above the head of Saint Stephen.

Plate 18 *Saint Francis and Saint Andrew. c.* 1595. Oil on canvas. 65 × 44 in. (167 × 113 cm.). Signed. Museo Nacional del Prado, Madrid.

El Greco would have been aware of the grand series of pairs of Saints painted by Navarrete for the chapels of the Church of the Escorial, the commission interrupted by the latter's death in 1579. From the time of the *Burial of the Count of Orgaz*, El Greco began to create his own images of the different Saints. Once a pattern was created, he kept closely to it. The pairing of Saints – the juxtaposition of two separate personalities, with their different spiritual significance – accentuates the individual characters. Saint Peter and Saint Paul, the two Saint Johns, were more obvious juxtapositions, but he also brought together such unlikely characters as in the present painting – the one, the some-what austere Apostle and Martyr of the time of Christ; the other, the ecstatic and 'gentle' Saint of the Middle Ages. The landscape also is double. The Saint Francis derives from the figure on the left of the *Burial of the Count of Orgaz* (plate 16), and has become more spiritualised; the Saint Andrew is the same type as that of the Talavera painting of 1591, and the gesture is a remarkable development of the similar gesture of the Saint Maurice, in the Escorial painting (plate 14), and eventually, indeed, can be traced back to the early *Healing of the Blind* (plate 3).

Plate 19 *Saint Francis in Prayer. c.* 1595. Oil on canvas. 58 × 41½ in. (147 × 105 cm.). Signed. M.H. de Young Memorial Museum, San Francisco. Samuel H. Kress Collection.

Saint Francis kneeling in prayer before the Crucifix and Skull. Pacheco, El Greco's contemporary (and the master of Velasquez) considered him to be the foremost painter of Saint Francis; and he did portray the Saint more often than any other, the earliest dating from the beginning of his career in Venice. A number of distinct variations exist. His most splendid interpretation of the 'gentle' Saint is probably the present painting (in plate 18, where he appears in the company of Saint Andrew, his ascetic character is brought out; and likewise, in the interpretation of the Saint meditating on Death (Ottawa), in transport before his Vision of the Flaming Torch (Cadiz), or receiving the Stigmata, while the essential meekness is present, it is allied to the special drama of the events). The painting was probably conceived shortly before El Greco embarked on the two large commissions on which he must have worked during the years 1597 to 1600.

Plate 20 *The Holy Family and Saint Mary Magdalene. c.* 1590–95. Oil on canvas. 51⅞ × 39½ in. (131 × 100 cm.). Not signed. Cleveland Museum of Art, Ohio. Gift of the Friends of the Cleveland Museum of Art, in memory of J.H. Wade.

A number of variations of the image of the Holy Family were painted by El Greco in Spain, comparable in pattern, in which the Virgin and Child and Saint Joseph appear either alone or in the company of Saint Anne or Saint Mary Magdalene. The last type inspired the splendour of the colour and rhythmical arrangement and handling of the Cleveland version, the artist's finest interpretation of the image. A few years later he was to introduce the same Virgin and Child in one of his paintings for the Chapel of San José, Toledo, painted 1597–99 (plate 28).

Plate 21 *The Agony in the Garden. c.* 1595. Oil on canvas. 40¼ × 44¾ in. (102 × 114 cm.). Signed. Toledo Museum, Ohio.

One of El Greco's most dramatic compositions, and one of the most moving interpretations of Christ's Agony, commensurate with that of the Scriptures. The Agony is superbly expressed in the design and treatment; in the harsh shape of the rock that rises behind Christ: in the hard lines of the ground at His feet and the piercing accents of the bared branches; in the tormented treatment of the sky; and in the strident light that strikes and envelopes the figure of the Saviour. '*O my Father, if this cup may not pass away from me, except I drink it, thy will be done*', (Matthew, XXVI, 42). The Angel holds the Cup before Christ; and below, the Apostles sleep in a womb-like recess in the rock. To the right, the 'band of men and officers from the chief priests and Pharisees' approach 'with lanterns and torches and weapons'. This is one of the rare paintings of horizontal format executed in Spain. Later versions of the subject by El Greco were designed as vertical compositions.

Plates 22, 23, 24, 25 Paintings for the high altar of the Colegio de Doña María, Madrid.

Begun December 1596, completed July 1600. The retable no longer exists, and the paintings are dispersed. The subjects of the paintings of the retable are not recorded, but according to Cean (Diccionario de Bellas Artes, 1800) they illustrated the Life of Christ. Judging by the size, style and subject matter, it can be assumed that the following paintings probably came from the retable: the Annunciation, the widest painting, in the centre (the church was dedicated to the Virgin of the Annunciation); the Adoration of the Shepherds and the Baptism of Christ, two paintings of the same size, on the left and right of the Annunciation; the Crucifixion above the Annunciation; and the Resurrection and Pentecost, another pair of identical size, flanking the Crucifixion (the whole forming a retable of a type known in the Escorial). Such an arrangement gives a chronological sequence to the events of the Life of Christ. The payment of 6000 ducados (for the paintings and retable) indicate a large commission. Small versions, probably models, exist for the three paintings more generally accepted as belonging to the retable, the Annunciation, the Adoration of the Shepherds and the Baptism of Christ.

Plate 22 *The Annunciation.* 1596–1600. Oil on canvas. 124 × 68½ in. (315 × 174 cm.). Signed. Museo Belaguer, Villanueva y Geltrú. On loan to the Museo Nacional del Prado, Madrid.
Surely El Greco's masterpiece of colour. The painting originally occupied the central position in the retable of the Colegio of Doña María de Aragón, and was probably the

first of the paintings to be completed. This painting and the *Crucifixion* (plate 23) are the two widest of the series. The *Crucifixion* was designed to be placed immediately above the *Annunciation*, and the two are intimately related to each other in composition. Already, in Santo Domingo el Antiguo, in Toledo, his first commission in Spain, El Greco had sensibly related together the two central paintings of the High Altar, the *Assumption* and *Trinity* (see plates 8 and 9). Again there is this compositional relationship, but there is also something more in this bringing together of the two so diverse yet intimately related themes of the Virgin's reception of the Holy Ghost, and Christ's giving up of the Holy Ghost. The Annunciation represents one of the Joys of the Virgin, and the Crucifixion incorporates one of Her Griefs. The central zone of the *Annunciation*, with the Flames and the Dove, is continued upwards in the Christ of the Expiration on the Cross; the figure of the Archangel Gabriel has its counterpart in the figure of Saint John; and the Virgin of Joy, of the *Annunciation*, appears above, in the *Crucifixion*, as the Virgin of Grief. The splendour of colour, appropriate to the supreme Joy of the Virgin, gives place to the very different drama of the Crucifixion; and similarly, each design and its treatment has its distinct tempo, consonant with the particular significance and dramatic demands of the two events. A comparison of the two Virgins is especially telling.

Plate 23 *The Crucifixion.* 1596–1600. Oil on canvas. 123 × 66½ in. (312 × 169 cm.). Signed. Museo Nacional del Prado, Madrid.

Christ on the Cross, at the moment of expiration, with the Virgin and Saint John, and at the foot of the Cross, the Magdalene. Originally above the *Annunciation*, in the retable of the Colegio of Doña María (see note to plate 22). This painting of the *Crucifixion* is one of the great interpretations of the subject in painting and almost inevitably brings to mind two other great Crucifixions, Grünewald's of the Isenheim Altar and Giotto's of the Arena Chapel. El Greco has introduced more symbols embodying spiritual emotions: the clamouring angels with outstretched arms encircling the Body of Christ – strangely recalling Giotto's painting – and the remarkable figure of the angel at the foot of the Cross.

Plate 24 *The Baptism of Christ.* 1596–1600. Oil on canvas. 137 × 56 in. (350 × 144 cm.). Signed. Museo Nacional del Prado, Madrid.

Probably originally on the right of the retable of the Colegio de Doña María, balancing the *Adoration of the Shepherds*, and painted at the same time. A small version, possibly the model for the large painting, is in the Galleria Corsini, Rome. A later development of this subject, only treated once before, in the *Modena Triptych* (plate 2), is the painting for the Hospital de San Juan Bautista, Toledo, probably completed after his death by Jorge Manuel. The pose of the Christ is related to that of the *Saint Sebastian* of *c.* 1580. The bipartite composition can be related to the *Burial of the Count of Orgaz* (plate 16), the portraits giving place to the range of angels. The splendid ecstatic figure of the angel, between the Baptist and Christ, is one of a number of such symbols that he began to introduce into his painting. If his figures – the actual participants in the action – become increasingly dematerialised, these new symbols appear as emotions materialised in gesture and colour.

Plate 25 *The Pentecost.* 1596–1600? Oil on canvas. Originally arched top. 108½ × 50 in. (275 × 127 cm.). Signed. Museo Nacional del Prado, Madrid.

Certainly a pair to the *Resurrection* (not shown) and almost certainly painted for the Colegio de Doña María. The two paintings appear to be of the same date, that is, the last to be painted for the Colegio. There are, however, certain passages in this painting that suggest overpainting or finishing by another hand (Jorge Manuel's?), which could point to a separate contract for this pair of paintings for the college. He was late in finishing the commission and there were difficulties in collecting moneys from the College – was the last of the series left unfinished, and completed later by his son? The Apostle second from the right is certainly a portrait of the artist, and the same portrait appears in the *Marriage of the Virgin*, one of his last works.

Plates 26, 27, 28
Paintings for the high altar and side altars of the Chapel of San José, Toledo. Begun end 1597; completed end 1599.

The Chapel dedicated to Saint Joseph, Saint Teresa's favourite Saint – '*the Father of my Soul*' – for it was the original intention of the founder, Martín Ramírez (d. 1595) to build a chapel for her (d. 1582). The paintings for the high altar (still in place) were the *Saint Joseph and the Christ Child* (plate 26), and above, the *Coronation of the Virgin*; and, for the side chapels, the *Saint Martin and the Beggar* and the *Virgin and Child with Saints* (plates 27 and 28).

Plate 26 *Saint Joseph and the Christ Child*. 1597 – 99. Oil on canvas. 114 × 58 in. (289 × 147 cm.). Signed. Chapel of San José, Toledo.

The central painting of the high altar and probably the first of the series to be painted for the Chapel of San José. Saint Joseph is shown as a figure of trust and protection to the Christ Child, who indicates the way. The colours, the rhythm of the tower-like figure of Joseph, express perfectly the meaning of the painting. There is no 'mannerist' ambiguity in the relationship of figure to setting. The subject is a parallel to that of Saint Anne teaching the Virgin, and is an extract from the theme of the Christ Child walking between the Virgin and Saint Joseph. It is at this time that El Greco begins to include a view of Toledo in his paintings. The view here is that of the Metropolitan Museum painting (Plate 29). The small signed version in the Museo de Santa Cruz is probably the model for the painting.

Plate 27 *Saint Martin and the Beggar*. 1597–99. Oil on canvas. 75¼ × 38½ in. (191 × 98 cm.). Signed. National Gallery of Art, Washington, D.C. Widener Collection.

Saint Martin shares his cloak with the beggar. Painted for the side altar, on the Gospel side (left) of the Chapel of San José, and probably after the paintings for the main altar. The bridge over the Tagus, as it appears in the *Saint Joseph and the Christ Child* (plate 26), is discernible near the raised hoof of the horse. The dedication to Saint Martin is probably a reference to the founder, Martín Ramírez.

Plate 28 *The Virgin and Child, with Saint Martina and Saint Agnes*. 1597–99 Oil on canvas. 76 × 41½ in. (193 × 105 cm.). Signed (with initials on the head of the lion). National Gallery of Art, Washington, D.C. Widener Collection.

Saint Martina with the lion; Saint Agnes with the Lamb. Painted for the side altar, on the Epistle side (right) of the Chapel of San José, and probably after the paintings for the main altar. The more schematic composition is appropriate to the image, but the angularity of the early *Immaculate Conception* has gone. The image of the Virgin and Child, alone or as a Holy Family, was one of El Greco's most popular subjects, and a number of versions follow this basic pattern for the Virgin and her Child. The inclusion of Saint Martina may also be a reference to the name of the founder.

Plate 29 *Toledo*. 1597–99. Oil on canvas. 47½ × 41¾ in. (121 × 106 cm.). Signed. Metropolitan Museum of Art, New York. Bequest of Mrs H. O. Havemeyer, 1929, the H. O. Havemeyer Collection.

The fact that an identical view appears in the *Saint Joseph and the Christ Child* (plate 26) suggests that the painting was conceived in connection with the San José commission (1597–99). From that time, the town features in many of his paintings: in the *Laocöon* (plate 30), the *Christ in Agony on the Cross* (plate 34), the *Immaculate Conception* (plate 44; again repeating this view), in all of which it takes on an apocalyptical character appropriate to the themes. In his late *Saint John the Baptist in the Wilderness* (plate 36) the landscape of the Escorial is appropriately introduced. This is one of the earliest independent landscapes in Western art and one of the most dramatic and individual landscapes ever painted. It is not just a 'View of Toledo', although the topographical details are correct; neither is it 'Toledo at night' or 'Toledo in a storm', other titles which have been attached to the painting: it is simply 'Toledo', but Toledo given a universal meaning – a spiritual portrait of the town. In introducing the view into his paintings he acknowledges how much his art owed to the inspiration of the town, until a few years before the great Imperial Capital and still the great ecclesiastical and cultural centre of Spain – the town isolated on the plain of Castile which he had made his new home, so far from the island of his birth. El Greco painted another view of the town as an independent subject, the *View and Plan of Toledo* in the Museo del Greco, Toledo, with the

vision of Saint Ildefonso and the Virgin poised above the Cathedral (figure 7).

Plate 30 *The Laocöon.* 1600–10. Oil on canvas. 56 × 76 in. (142 × 193 cm.). Not signed. National Gallery, Washington, D.C. Samuel H. Kress Collection.

In the background, a view of Toledo, as Troy, and the Trojan Horse. El Greco would have known the sculptured group in Rome, uncovered at the beginning of the sixteenth century, but more significantly he would have known the original story, which he has interpreted in an entirely independent way. This is the only known painting of classical subject matter by El Greco, and he does seem to give it a special spiritual meaning. The horizontal format is uncharacteristic of his works in Spain, which become increasingly more elevated in composition and spirit. The essential verticality of the composition is made clear, however, by the high horizon and the upward movement of the flanking figures. The view of Toledo appears to have been taken from the same viewpoint as that of the Metropolitan Museum painting (plate 29), which it continues to the right, the two together completing the panorama of the town. The panoramic *View and plan of Toledo* in the Museo del Greco, Toledo, is taken from a different viewpoint. Recent cleaning has uncovered a third figure in the group on the right, which El Greco had overpainted.

Plate 31 *Christ Driving the Traders from the Temple* (The Cleansing of the Temple) *c.* 1600. Oil on canvas. 41¾ × 51 in. (106 × 130 cm.). Not signed. National Gallery, London.

A late version of the subject treated twice in his Italian years. The scene is restricted to the main group, which follows almost exactly that of the original design of some forty years back (plate 5), which in its turn used a Michelangelo design. A greater expressive force is attained by this concentration on the one group, and is infinitely enhanced by the vitality of the colour and handling. The disturbing effect of the empty space on the right of his earlier versions, and of the recessional perspective of the tiled pavement and the vista through the arch has been eliminated. The three-dimensional character of the figures and space is not described: the event alone is expressed, and creates its own space. The episodal type of

subject is unusual for El Greco in Spain – he does not repeat the *Christ Healing the Blind* (plate 3), the possible sequel to this event. The subject was, of course, of special relevance to the age of the Counter-Reformation. In any event, El Greco has raised it above the merely dogmatic or episodal. The Venetian motif of the reclining female figure of the early versions has been substituted by the male figure bending down, which may again be a recollection from Raphael's tapestry cartoon of the *Miraculous Draught of Fishes*. The reliefs to the left and right of the arch represent the Expulsion from Paradise, an Old Testament parallel of the Expulsion from the Temple, and the Sacrifice of Isaac, less easily connected with the subject. In this late version, El Greco has introduced the overthrown 'tables of the moneylenders and the seats of those who sold doves' (St Matthew XXI, 12). Later versions exist, of which the National Gallery painting is the finest example. The splendid small version in the Frick Collection, New York, is probably the study for the larger painting.

Plate 32 *Cardinal Fernando Niño de Guevara. c.* 1600. Oil on canvas. 76½ × 51¼ in. (194 × 130 cm.). Signed. Metropolitan Museum of Art, New York. Bequest of Mrs H.O. Havemeyer, 1929, the H.O. Havemeyer Collection.

Niño de Guevara (1541–1609), Cardinal 1596, Inquisitor-General 1600, Archbishop of Seville 1601. Probably painted *c.* 1600, when Inquisitor-General, and certainly before he became Archbishop of Seville. One of a number of eminent ecclesiastics of Toledo portrayed by El Greco, and one of his finest portraits. The splendour and richness of colour is appropriate to the character and rank of the sitter. The frontal turn of the pose concentrates attention on the figure.

Plate 33 *Christ Carrying the Cross.* 1600–05. Oil on canvas. 42½ × 30¾ in. (108 × 78 cm.). Signed. Museo Nacional del Prado, Madrid.

El Greco treated the theme many times in Spain. The earliest date from soon after the *Espolio*, to which it is essentially related. The subject is not repeated, but the Christ becomes the prototype for the Christ Carrying the Cross.

Plate 34 *Christ on the Cross.* 1600–10. Oil on canvas. 41 × 24½ in. (104 × 62 cm.). Signed. Art Museum, Cincinnati.

The Christ in Agony on the Cross, with a view of Toledo. Another – and finer – version, is in the Museum of Art, Cleveland, but with part of the landscape cut away. Christ on the Cross is left alone '*and there was a darkness over all the earth . . . and the sun was darkened, and the veil of the Temple was rent in the midst*' (St Luke, XXIII, 44–45), and he commends his spirit to His Lord. El Greco was in sympathy with the apocalyptical atmosphere of the theme. From the time of the San José paintings, El Greco often chose to include a view of Toledo in his paintings.

Plate 35 *Portrait of the Artist's Son, Jorge Manuel. c.* 1603. Oil on canvas. 32×21 in. (81×56 cm.). Signed. Museo Provincial, Seville.

Jorge Manuel appears about the same age as in the *Virgin of Charity* (plate 38), painted 1603–05, that is, when he was twenty-five to twenty-seven years old. The young gentleman, of a certain aristocratic mien, displays elegantly the tools of his craft. It is one of his finest portraits, but it is with difficulty that one relates the personality to that of the *Saint Luke*. Jorge Manuel was not a remarkable painter like his father.

Plate 36 *Saint John the Baptist in the Wilderness. c.* 1600. Oil on canvas. 43¾×26 in. (111×66 cm.). Signed. M.H. de Young Memorial Museum, San Francisco. Samuel H. Kress Collection.

The painting is probably not far in date from the *Saint Bernardino*, dated in 1603 (figure 3). From 1597, the date of the *Saint Joseph and the Christ Child* (plate 26), El Greco introduced into his paintings, where appropriate, the town and landscape of Toledo; in this painting he aptly chooses the austere landscape of the Escorial as the setting (the Monastery of El Escorial is seen to the right of the Saint). While he must have visited the Escorial in 1579, when he received the commission from Philip II to paint the *Martyrdom of Saint Maurice and his Legions* for the Monastery (plate 14), he would most probably have made further acquaintance with the Escorial on the occasion of his commission for the Colegio of Doña María, Madrid, in 1596. No separate study of the Monastery and its landscape, like that of *Toledo* (plate 29), made in connection with his commission for the Chapel of San José, Toledo, is known.

Plate 37 *Saint Dominic in Prayer.* 1600–1610. Oil on canvas. 47½×34⅝ in. (120×88 cm.). Signed. Sacristy, Toledo Cathedral.

A comparison with the similar composition of *Saint Francis in Prayer* (plate 19) illustrates the advance made in the vitality and expressive quality of the brushwork.

Plates 38, 39, 40, 41 Paintings for the High Altar of the church of the Hospital de la Caridad, Illescas (Toledo province), begun 1603 and completed 1605.

Plate 38 *The Virgin of Charity* (Detail). 1603–05. Oil on canvas. 61×48½ in. (155×123 cm.). Not signed. Hospital de la Caridad, Illescas.

Painted for the High Altar of the Church of the Hospital de la Caridad, and now placed in a side altar, balancing the *Saint Ildefonso* (plate 42). El Greco was responsible for the whole of the decoration of the chapel, begun in 1603, and completed in 1605. All the portraits are of men of Toledo of his time. The ruffs had grown to rather exaggerated proportions in the twenty years from the time of the *Burial of the Count of Orgaz* (plate 16), and their introduction into the painting was censured by the Hospital authorities. At some time they were painted over, but have been recently restored. El Greco's son appears on the extreme right, at about the same age as in the portrait in Seville (plate 35).

Plate 39 *The Coronation of the Virgin.* 1603–05. Oil on canvas. 64×86½ in. (163×220 cm.). Not signed. Hospital de la Caridad, Illescas.

Painted for the vault of the main chapel of the church, and now exhibited in the vestry. The pattern follows closely that of El Greco's first treatment of the subject at Talavera in 1591 The design is effectively adapted to the oval field and to a viewpoint from below, as are also the flanking circular paintings (plates 40 and 41).

Plate 40 *The Annunciation.* 1603–05. Oil on canvas. Diameter 50⅜ in. (128 cm.). Signed. Hospital de la Caridad, Illescas.

Painted for the lunette to the left of the *Coronation of the Virgin* (plate 39), and now in the vestry of the church.

Plate 41 *The Nativity*. 1603–05. Oil on canvas. Diameter 50⅜ in. (128 cm.). Signed. Hospital de la Caridad, Illescas.

Painted for the lunette to the right of the *Coronation of the Virgin* (plate 39), and now in the vestry of the church.

Plate 42 *Saint Ildefonso*. *c.* 1602–03 or *c.* 1607–09. Oil on canvas. 62×40 in. (158×102 cm.). Signed. Hospital de la Caridad, Illescas.

In the side altar on the left of the main chapel of the church, balancing the *Virgin of Charity* (plate 38). Its original place in the church is not known. The painting is not mentioned in the incomplete documentation for the decoration of the chapel, and if, as is probable, it was not painted at the same time, it cannot date much before June 1603, the date of the contract, and was more likely painted soon after the conclusion of litigation in August 1607. In its present position, it makes a grand pair to the *Virgin of Charity*, and is one of the most splendid of his 'portraits' of Saints. It is difficult, and perhaps not proper, to separate his portraits of Saints from his actual portraits. In both he employs all his means of spiritual or psychological expression. The legend is that Saint Ildefonso, the first Bishop of Toledo, presented an image of the Virgin of the Mantle to a foundation of his in Illescas. The Saint is portrayed before the same image, as he wrote his dissertation on the Purity of the Virgin. The state of inspiration is brilliantly expressed. There is an infinite distinction in expression between the hand poised with the pen in this 'portrait' and the similar motif in the portrait of his son (plate 35).

Plate 43 *Fray Hortensio Félix de Paravicino*. 1609–10. Oil on canvas. 44½×34 in. (113×86 cm.). Signed. Museum of Fine Arts, Boston, Mass.

Portrait of his friend, the great Toledan poet (1580–1633). Paravicino, in his sonnet celebrating the portrait, tells us that it was painted when he was twenty-nine years of age. The complete frontality of the pose, the enormous simplicity, and the absence of any setting contribute to the feeling of spiritual presence, comparatively absent from the splendid portrait of Cardinal Guevara (plate 32). The inspired rhythm and handling is no less a living thing than the man himself. It is one of the masterpieces of portraiture of all time.

Plate 44 *The Immaculate Conception*. 1607–13. Oil on canvas. 127½×65¾ in. (323×167 cm.). Not signed. Museo de Santa Cruz, Toledo.

The great masterpiece of his last manner. Painted for the High Altar of the Chapel of Oballe, San Vicente, Toledo, begun 1607, finished 1613. In the chapel until 1961, when it was transferred to the Museo de Santa Cruz. The painting certainly represents the Immaculate Conception, although it has often been referred to as an Assumption. The various attributes of the Virgin (roses, lilies, mirror, fountain of clear water) proper to the representation of the Mystery, appear at the foot of the painting on the right. The same view of Toledo – but more ethereal – as in the painting in the Metropolitan Museum (plate 29), and in the *Saint Joseph and the Christ Child* (plate 26) appears on the left. The painting is the grand culmination of El Greco's career. No artist has been able to express so convincingly the infinite: an infinity of colour and light, as infinity of movement and of space. This expression of the spiritual reality of the universe was only possible to attain by the uncompromising disengagement of his art from the material and transitory of this World. The earth, symbolised by Toledo, is already a phantom. From the burst of rose and white flowers at the base, a great upsurge of movement – of colour and light, in constant flux – commences, and increases in its rapture, and met by the light of the Dove, becomes all-pervading and infinite. One cannot halt the rhythm any more than in music, yet the grand central image is always present. It is perhaps the most remarkable realisation of spiritual ecstasy in painting, and one of the greatest masterpieces of colour. A single detail – the offering of flowers, the Virgin's mantle transfigured by light – is a moving experience in itself.

Plate 45 *The Visitation*. 1610–14. Oil on canvas. 38¼×28 in. (97×71 cm.). Not signed. Dumbarton Oaks, Washington, D.C.

Possibly a study for the circular painting in the vault of the Chapel of Oballe, San Vicente, Toledo, above the *Immaculate Conception* (plate 44) of the high altar, specified in the contract. It does seem that the painting was originally within a circle, and that the canvas has been cut at the left and right. It may well be the last work produced by the master, and the

larger painting for the vault may never have been finished. The choice of subject of the Visitation is a reference to the name of the foundress of the Chapel, Isabel de Oballe. The process of dematerialisation is complete. There are only shapes, colour and light and the strange quality of the movement – of the 'meeting of two celestial bodies' (Camón Aznar, *Dominico Greco*, 1950).

Plate 46 *Saint Peter*. 1610–14. Oil on canvas. 81½×41½ in. (207×105 cm.). Not signed. Monastery of El Escorial.

Probably, with the *Saint Ildefonso* also in the Escorial, painted for the Chapel of Oballe of the church of San Vicente, Toledo, to be placed to the left and right of the *Immaculate Conception* (plate 44), where for some time there have been old copies. The first Pope and the first Bishop of Toledo make a sensible pair. The infinite upward movement and powerful rhythm of this monolithic image express supremely the spiritual meaning of the 'Prince of the Apostles' the 'Rock upon which the Church was built'. This is the final expression of the Saint 'image'.

Plate 47 *Saint Jerome Penitent*. 1610–14. Oil on canvas. 65½×43½ in. (166×110 cm.). Not signed. National Gallery of Art, Washington, D.C. Gift of Chester Dale.

The final expression of his 'Saint in ecstasy' (compare plates 12, 46). The pattern is still that of the *Saint Sebastian* of his first years in Spain, and it was employed also for the Christ of the *Baptism* (plate 24).

Plate 48 *The Vision of Saint John the Divine. – The Opening of the Fifth Seal*. 1610–14. Oil on Canvas. 88¼×76½ in. (224×194 cm.). Not signed. Metropolitan Museum of Art, New York. Roger's Fund, 1956.

One of his very last works. It is possibly connected with the commission, left unfinished on his death, for the Hospital de Tavera (Hospital de San Juan Bautista), Toledo. '*And when he had opened the fifth seal, I saw under the altar the souls of them that were slain for the word of God . . . And they cried with a loud voice . . . And white robes were given to every one of them . . .*' (Revelation of St John, VI, 9–11). The painting has been cut at the top, where there was possibly a representation of the Throne: '*And immediately I was in the spirit, and behold, a throne was set in heaven, and one sat on the throne . . . and round about the throne were four and twenty seats, and upon the seats I saw four and twenty elders . . . And I saw in the right hand of him that sat on the throne a book . . . sealed with seven seals . . .*' (Revelation of St John, IV–V). The transported figure of Saint John is on the left,; his vision of the resurrected martyrs, on the right. The Spirit as 'a living flame, striving upwards', and this strange compatibility of infinite darkness and 'all-consuming light' is met with in the writings of the mystics of his time, Saint Teresa of Jesus and Saint John of the Cross. El Greco realises the apocalyptical vision in colour, light and movement. The painting fittingly closes his career.

Plate 49 *The Adoration of the Shepherds*. Oil on canvas. 1612–14. 126 × 70¾ in. (320×180 cm.). Not signed. Museo Nacional del Prado, Madrid.

El Greco painted this work – on which alone his great reputation could surely stand – for his own burial vault in the church of Santo Domingo el Antiguo, Toledo, the church for which he painted his first works in Spain. The painting was executed sometime between the renting of the vault in 1612 and his death in 1614. The aged painter is almost certainly seen in the shepherd who kneels before the Virgin and Child in the foreground.

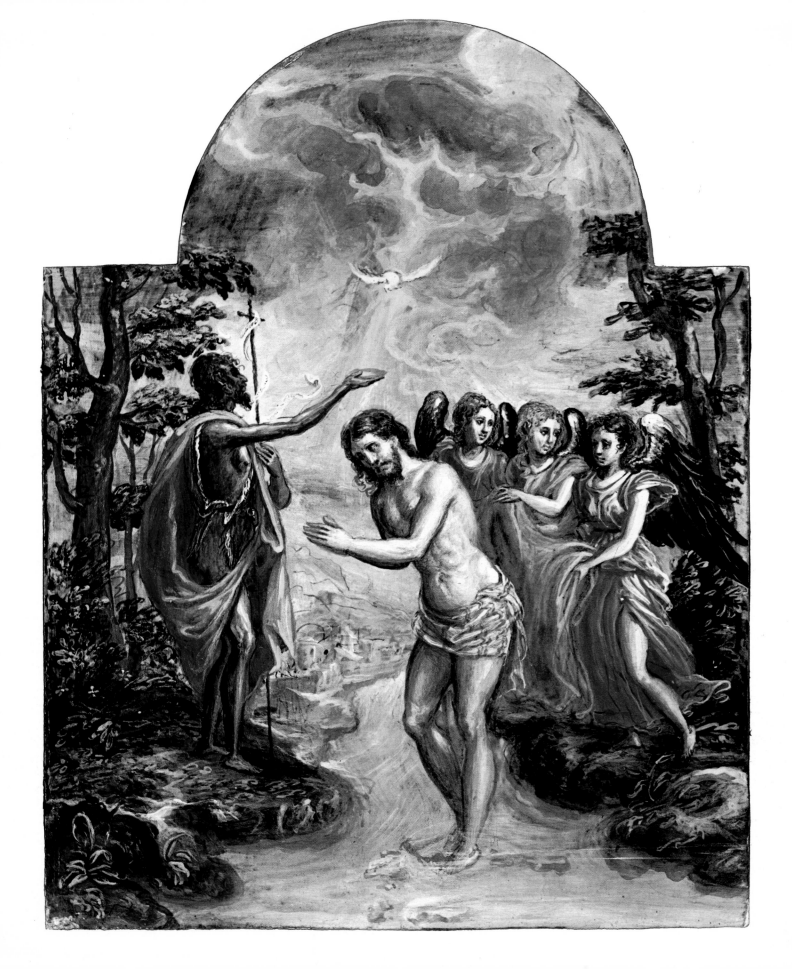

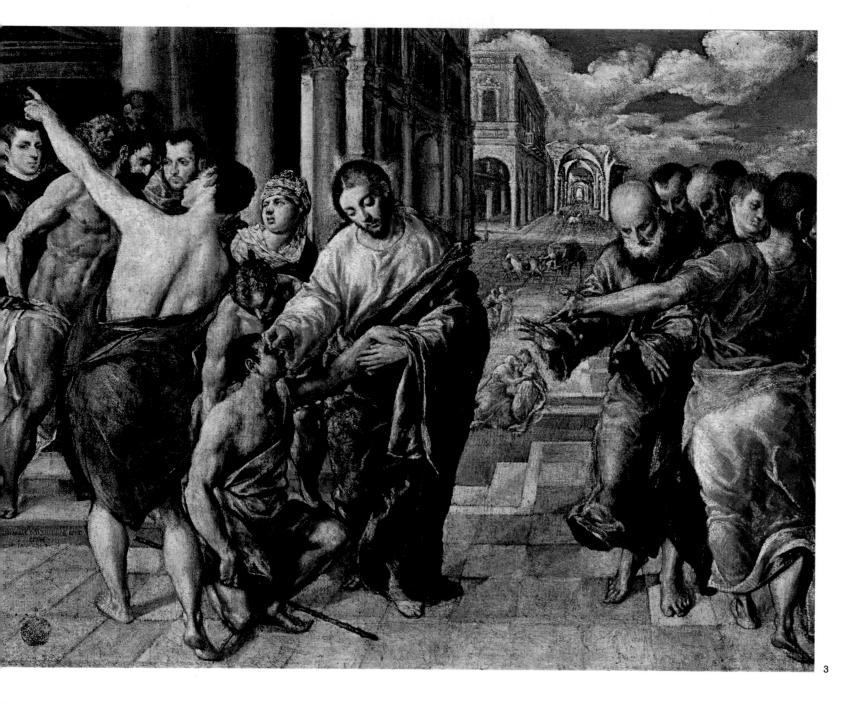

3

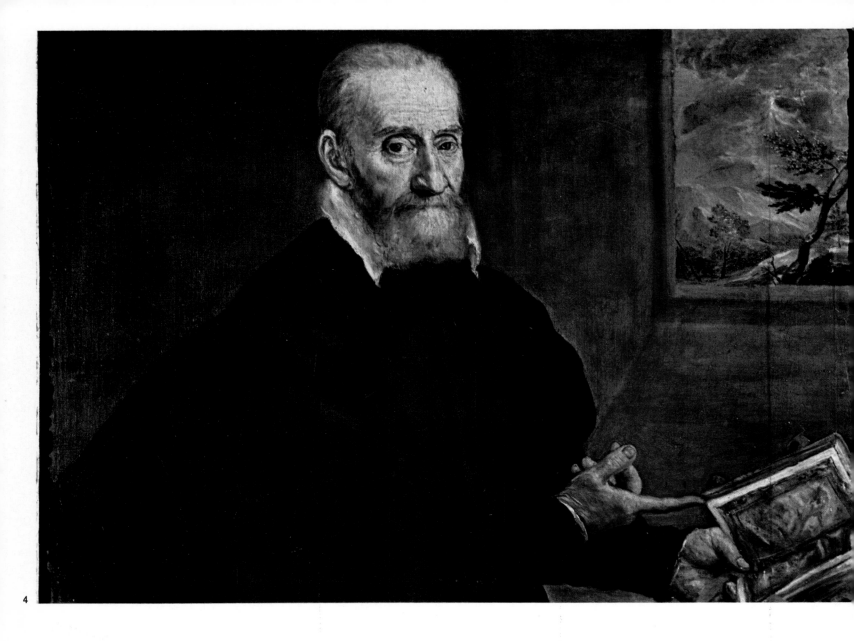

4

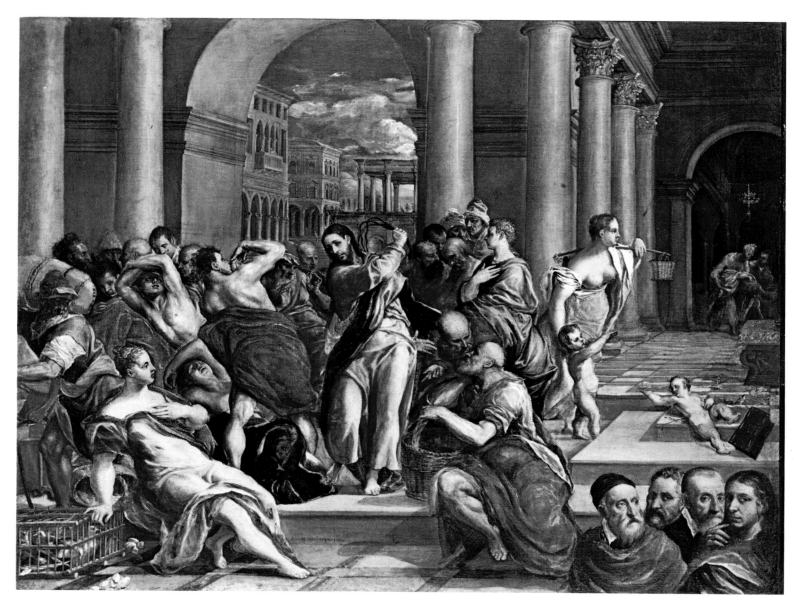

5

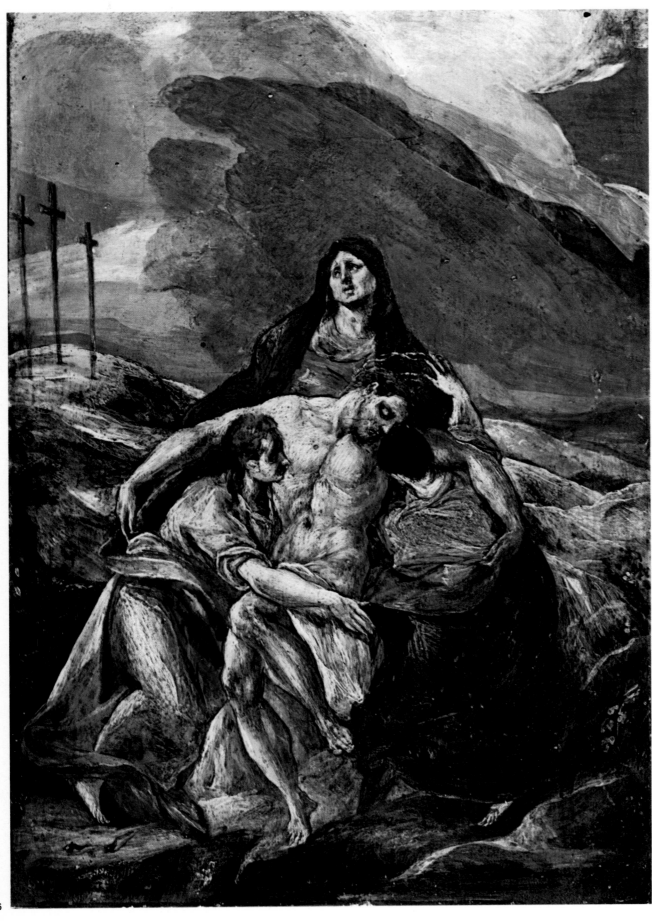

6

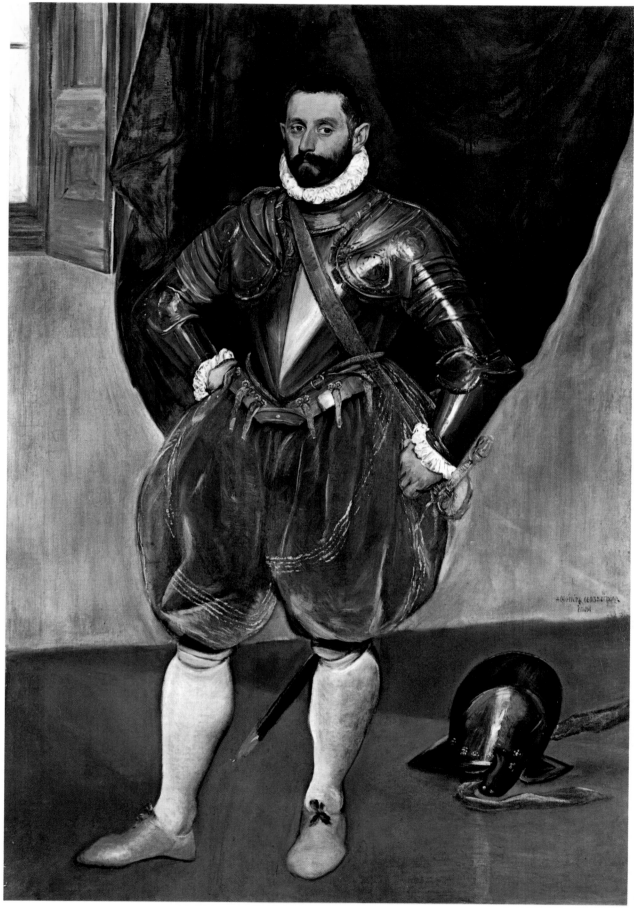

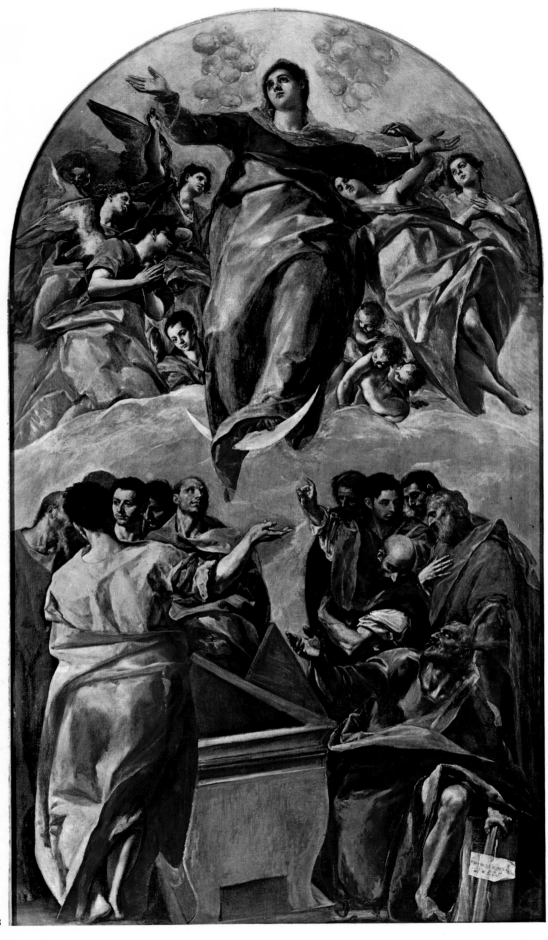

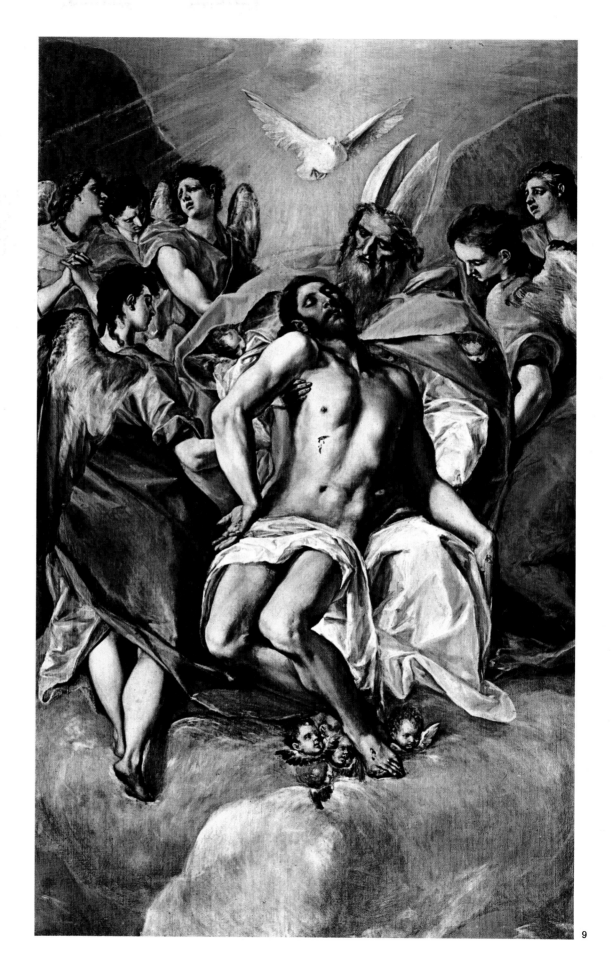

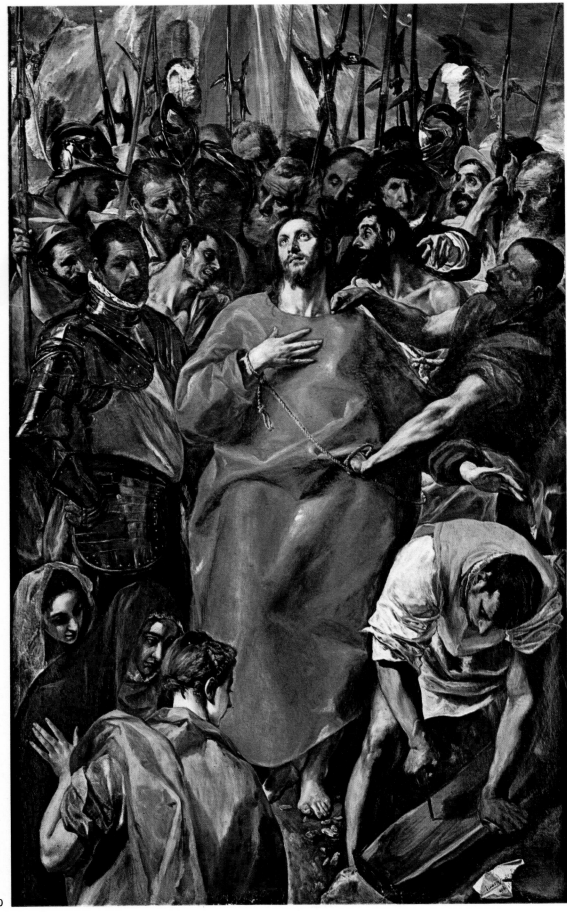

10

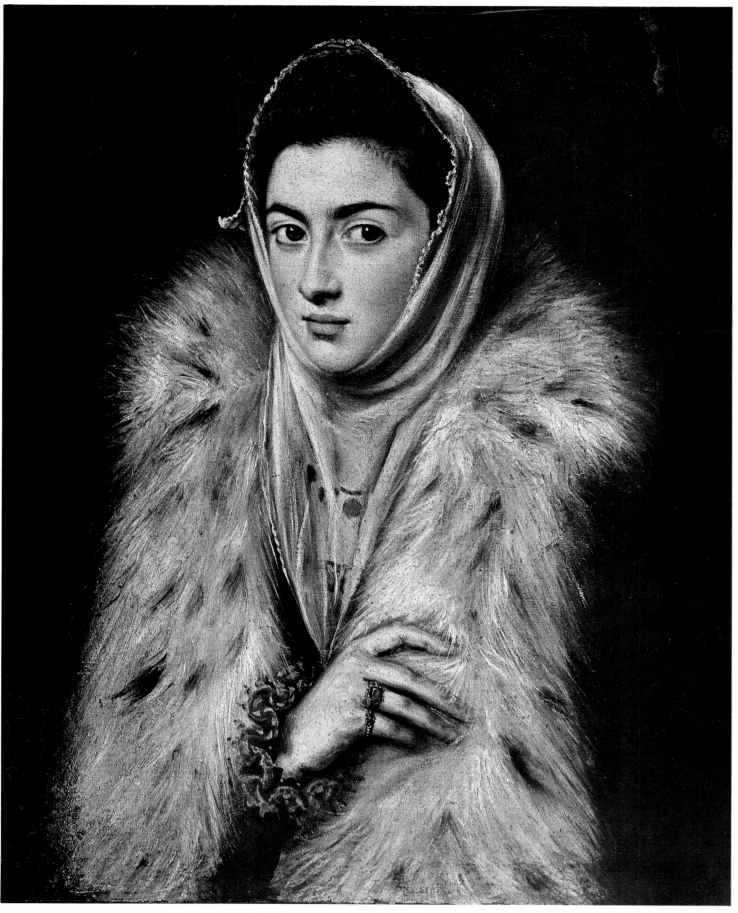

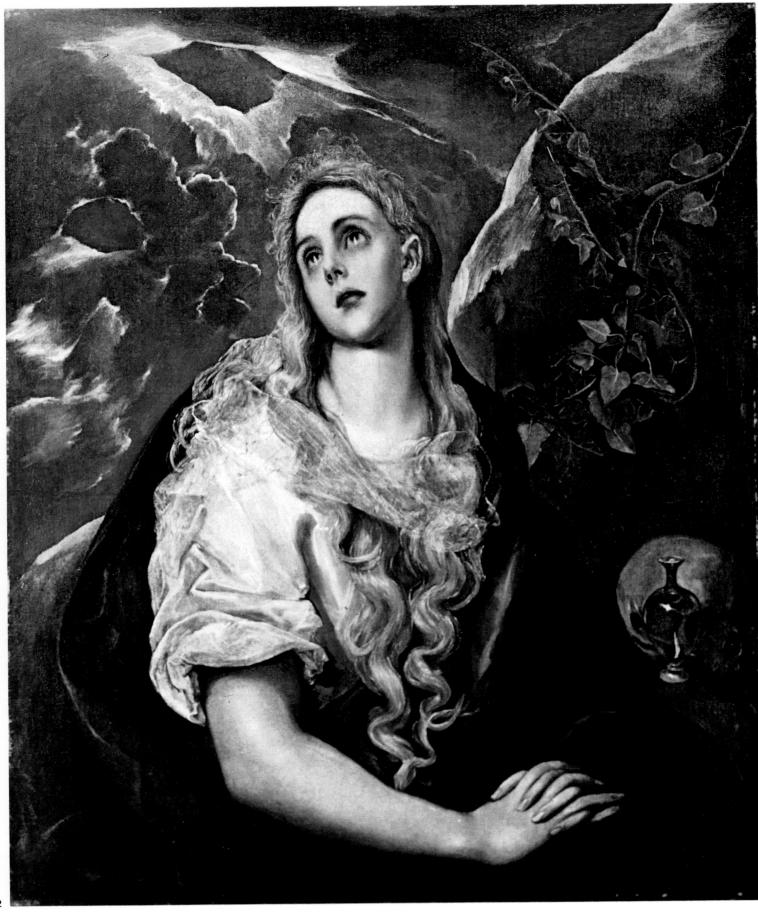

12

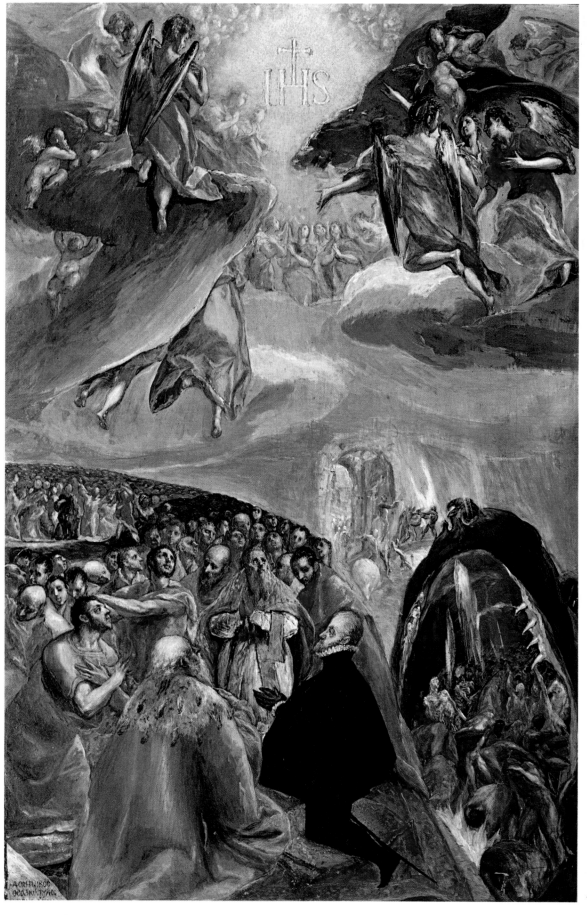

13

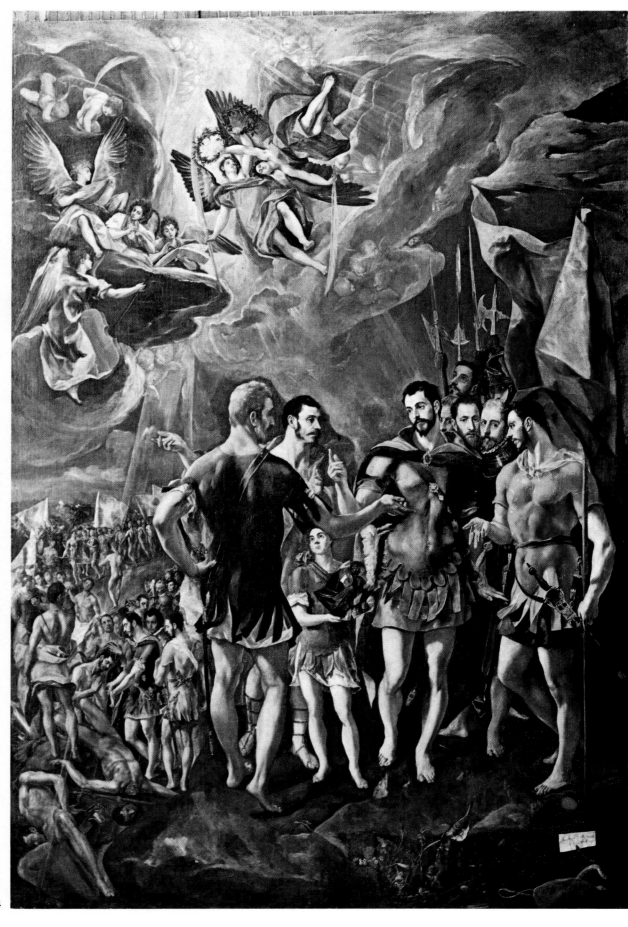

14

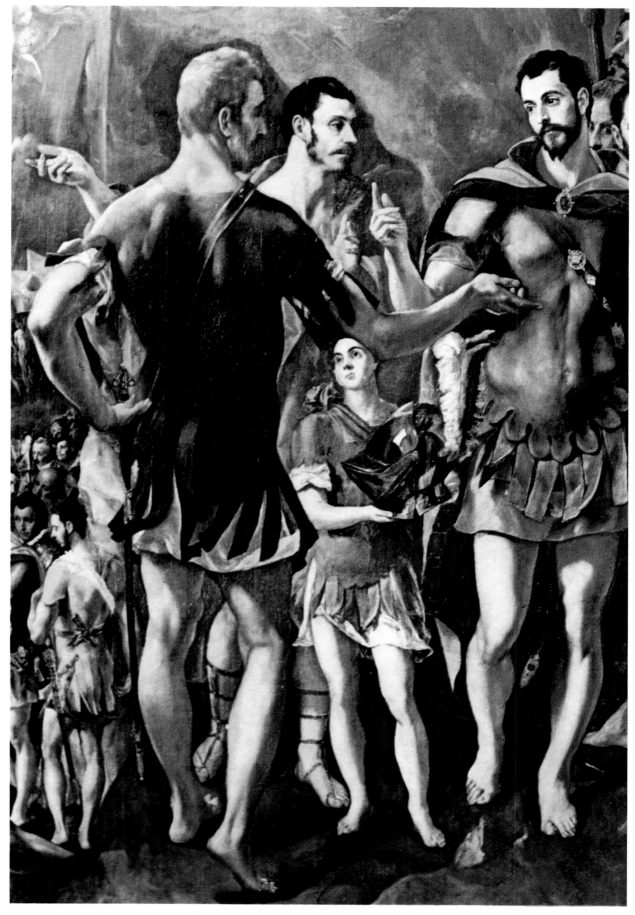

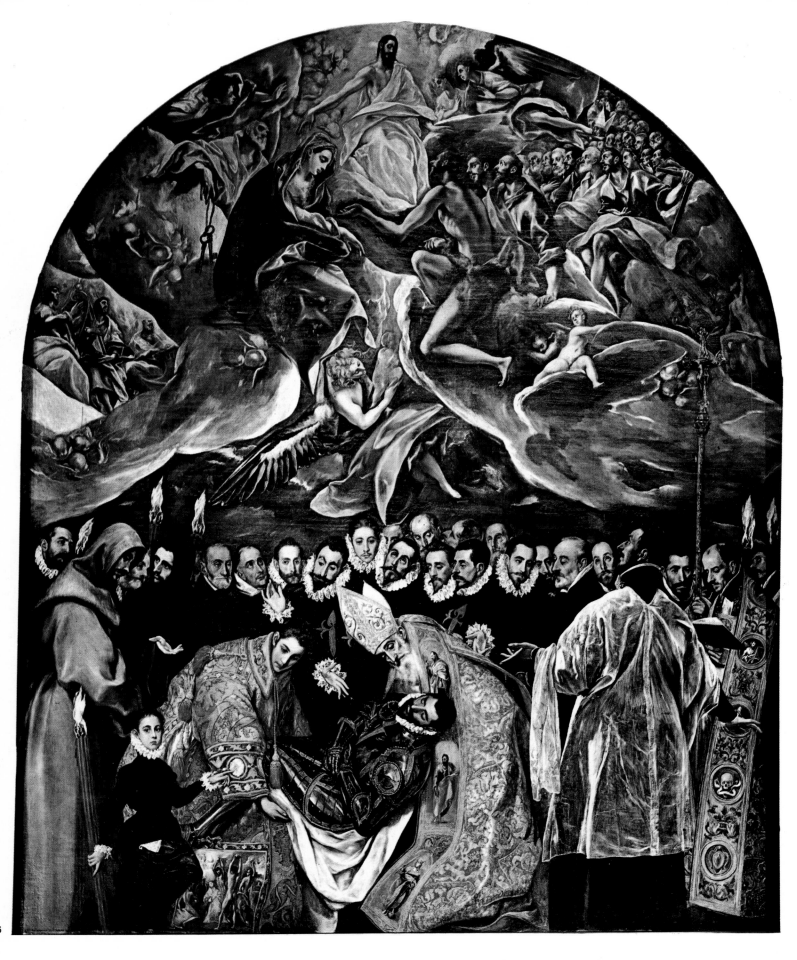

16

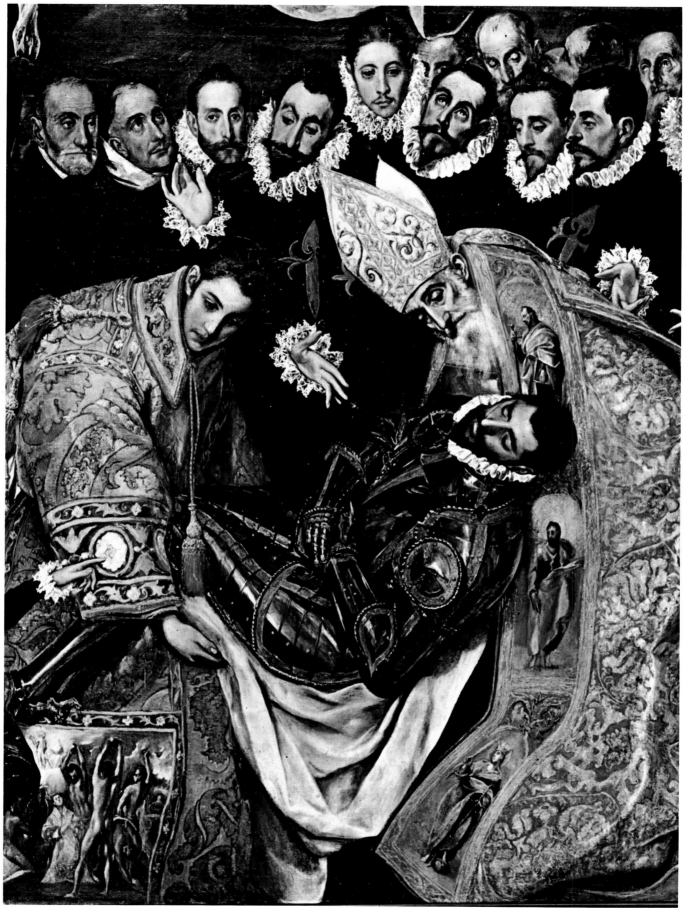

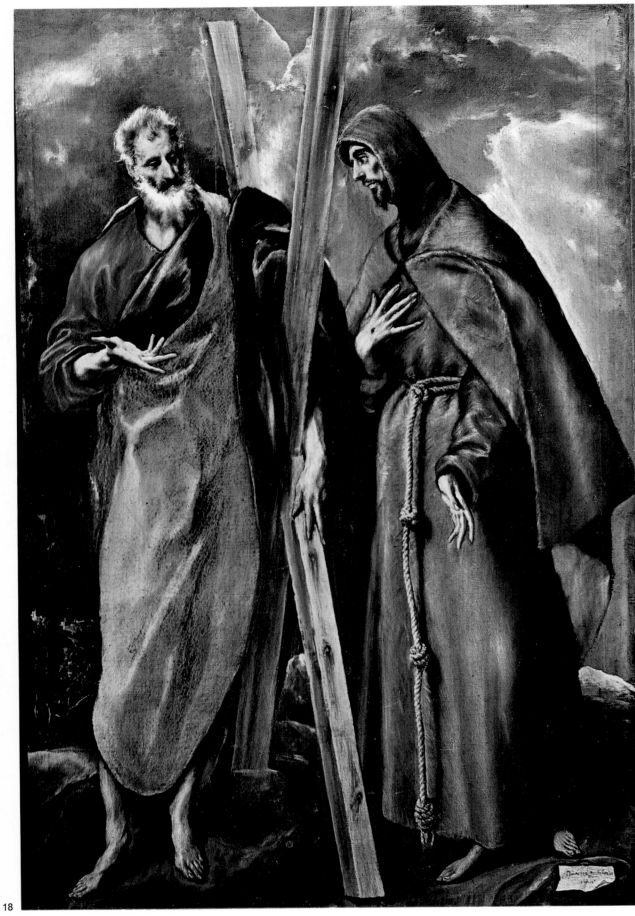

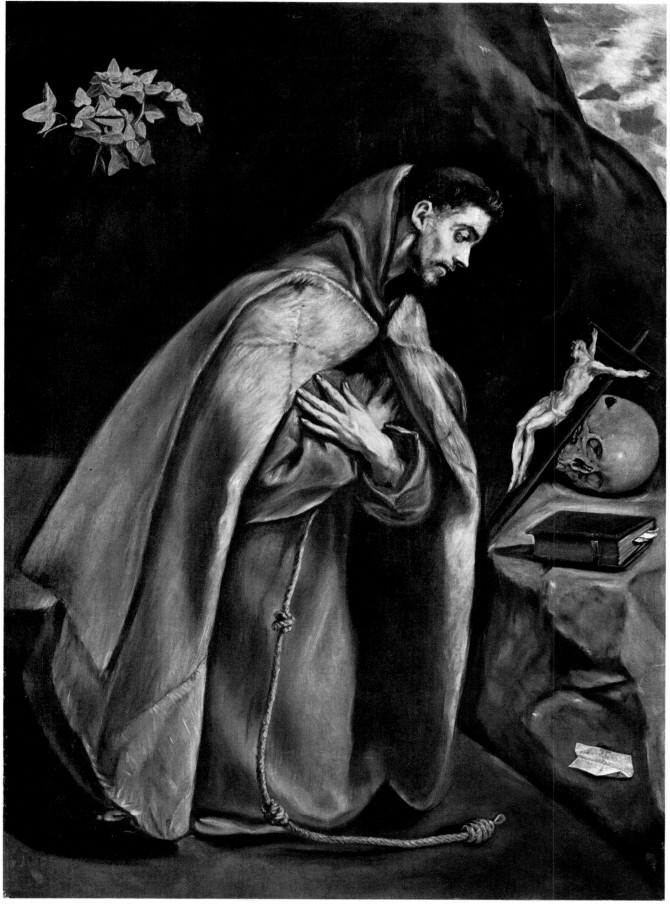

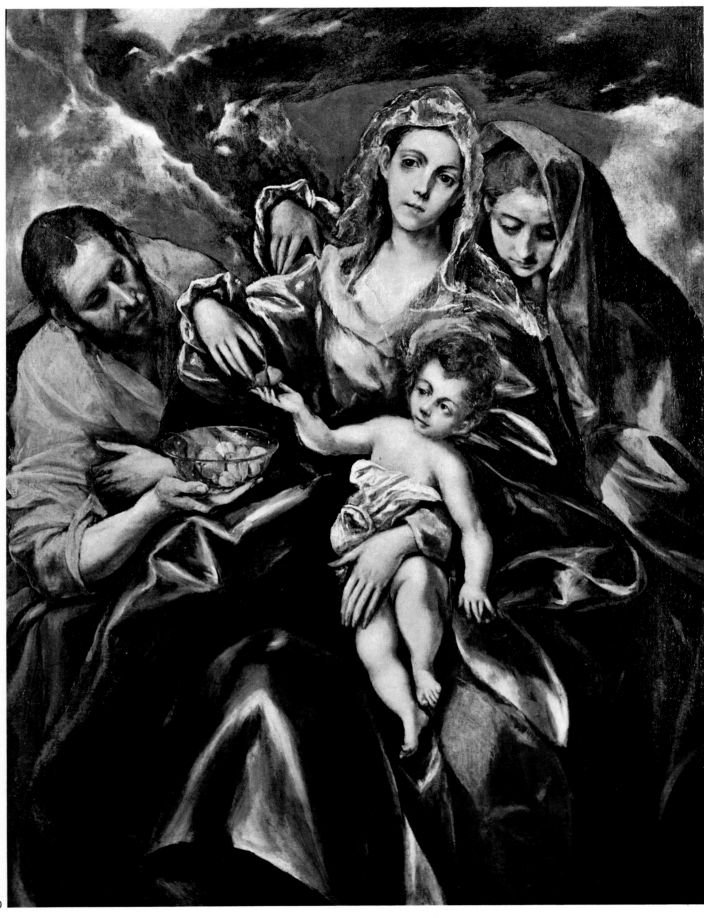

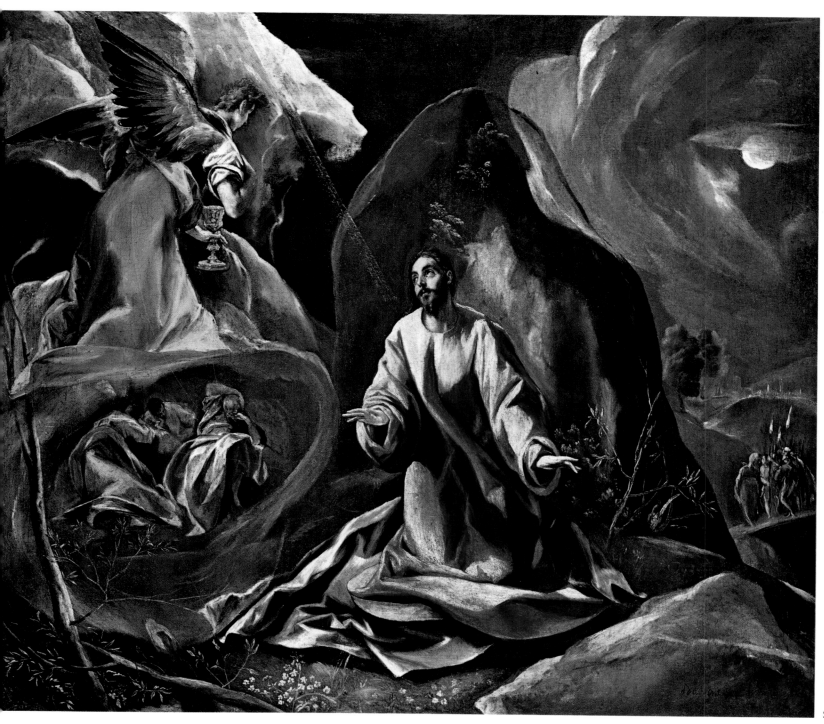

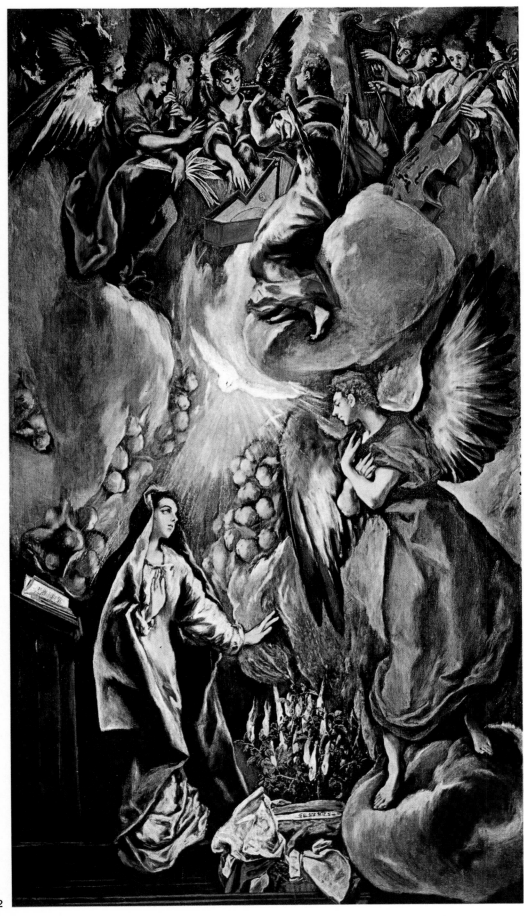

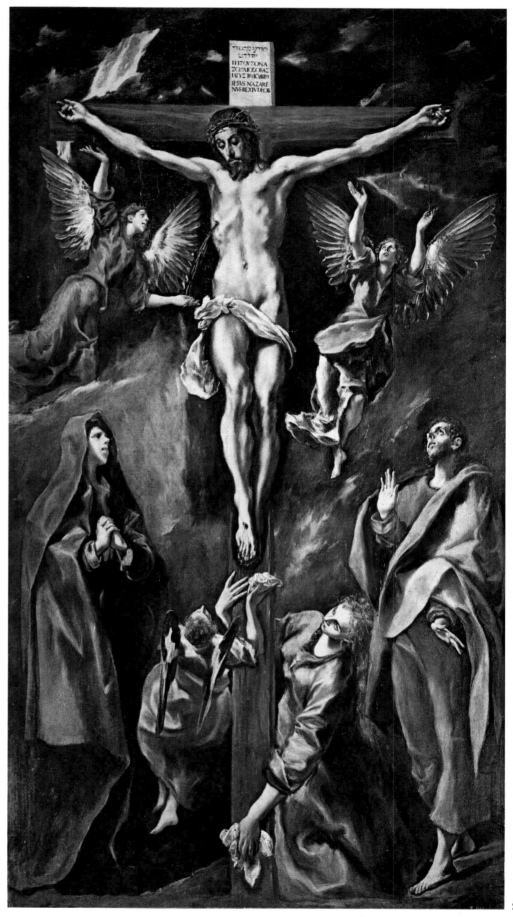

23

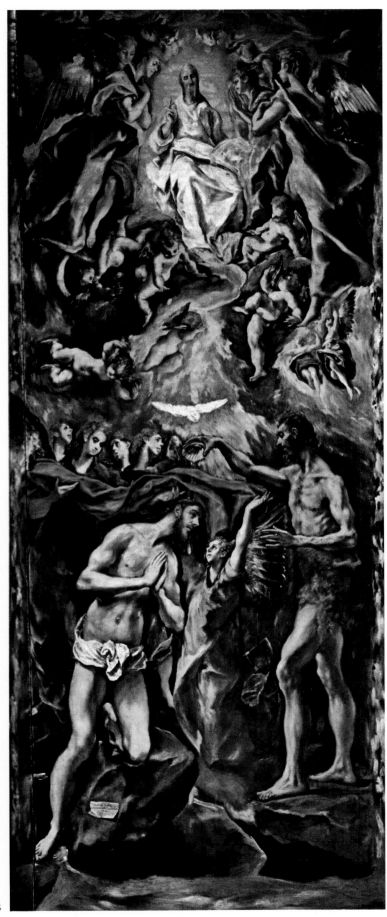

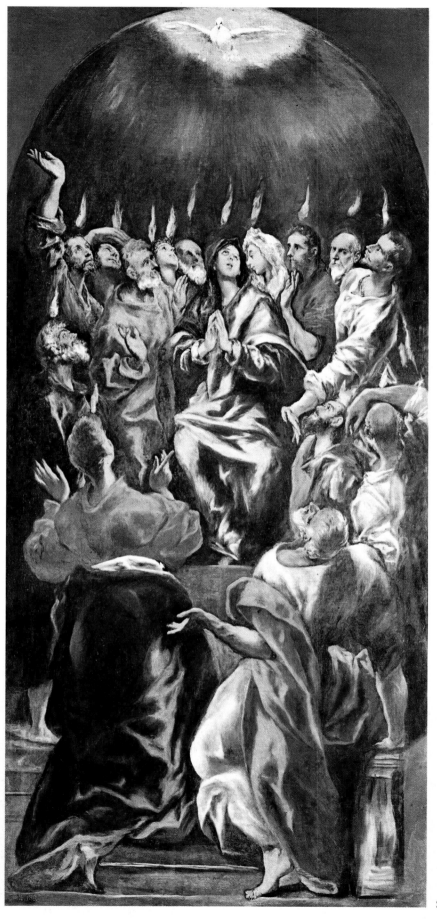

25

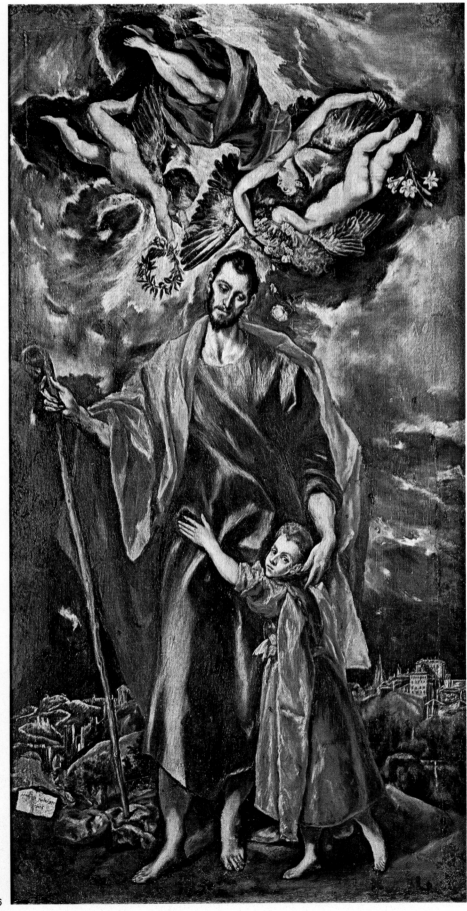

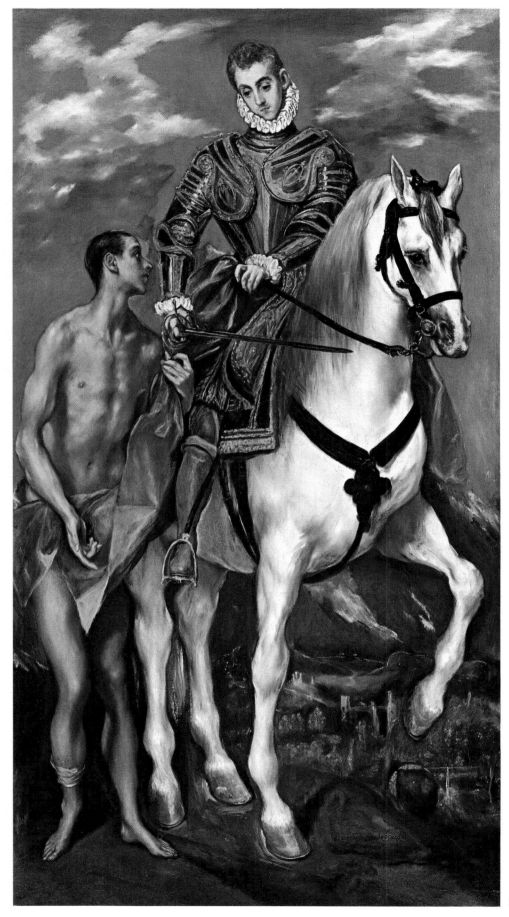

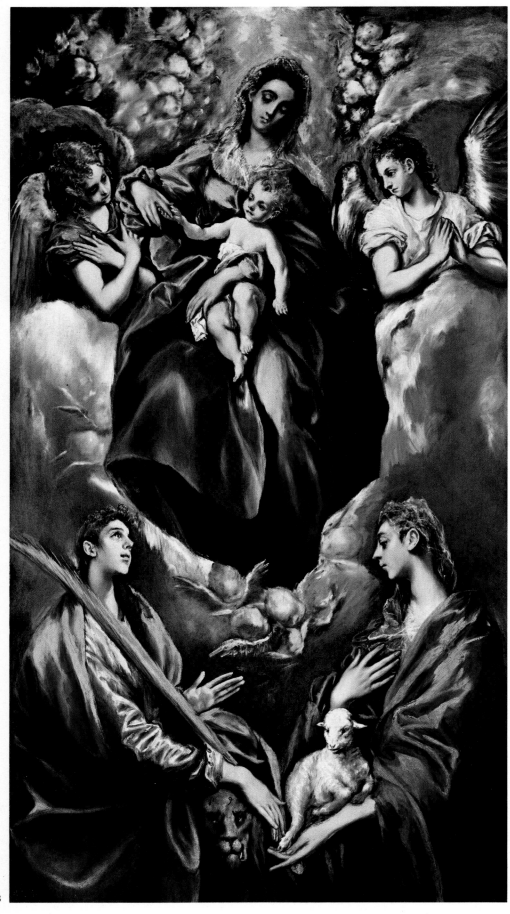

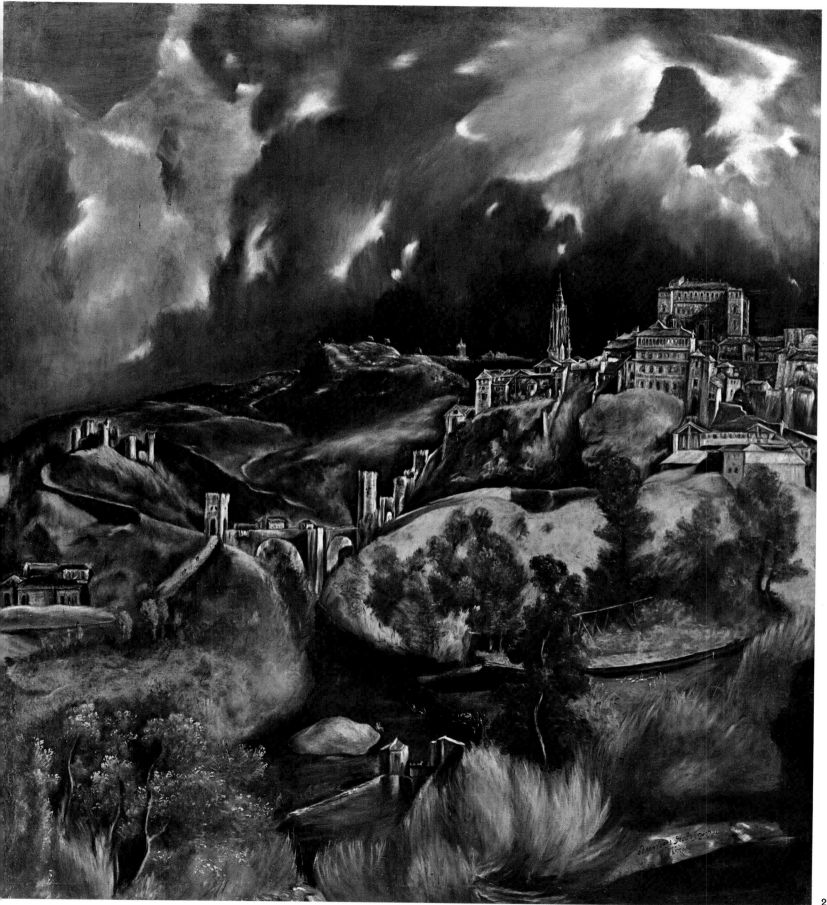

30

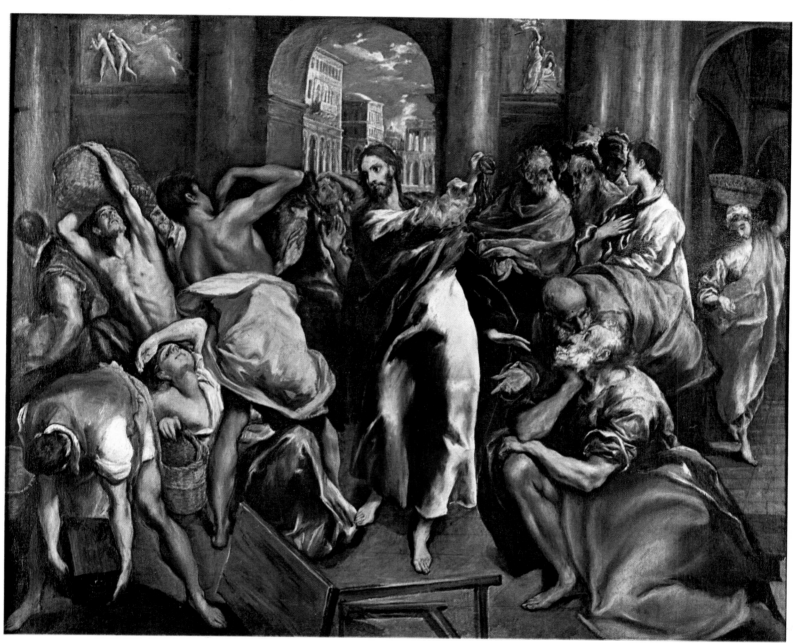

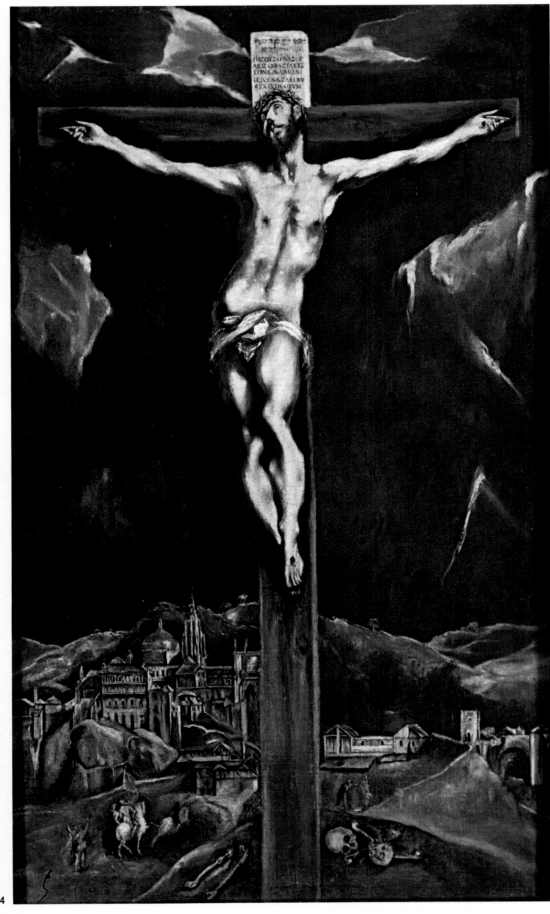

34

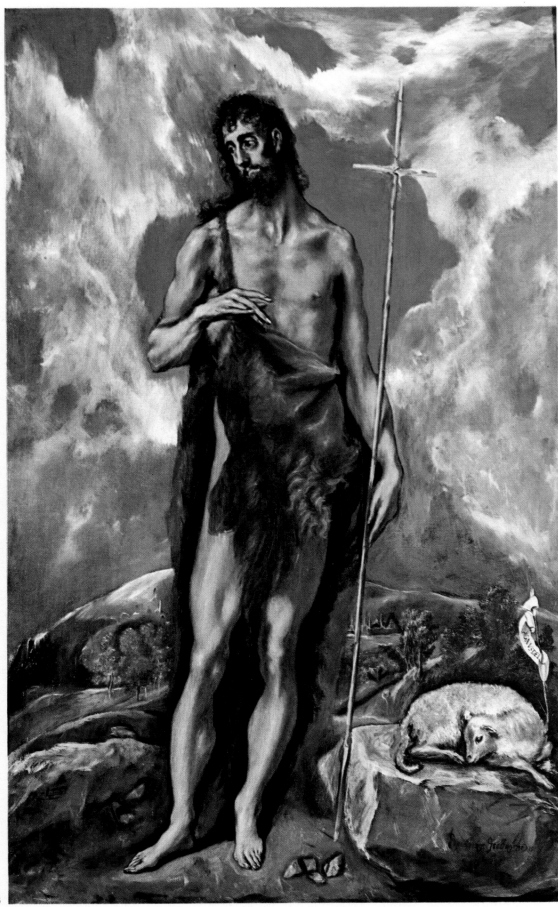

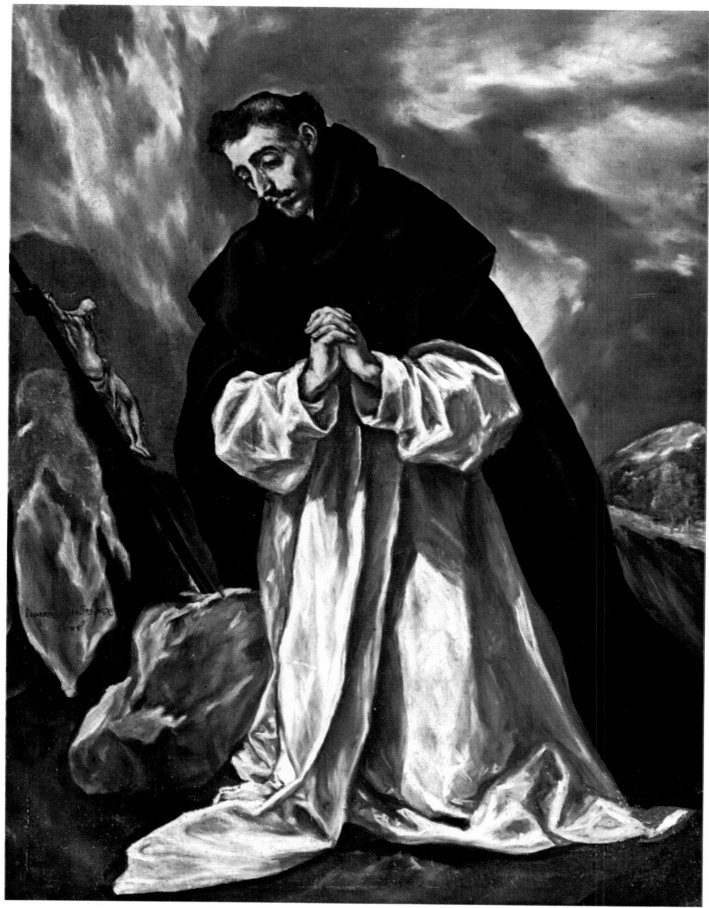

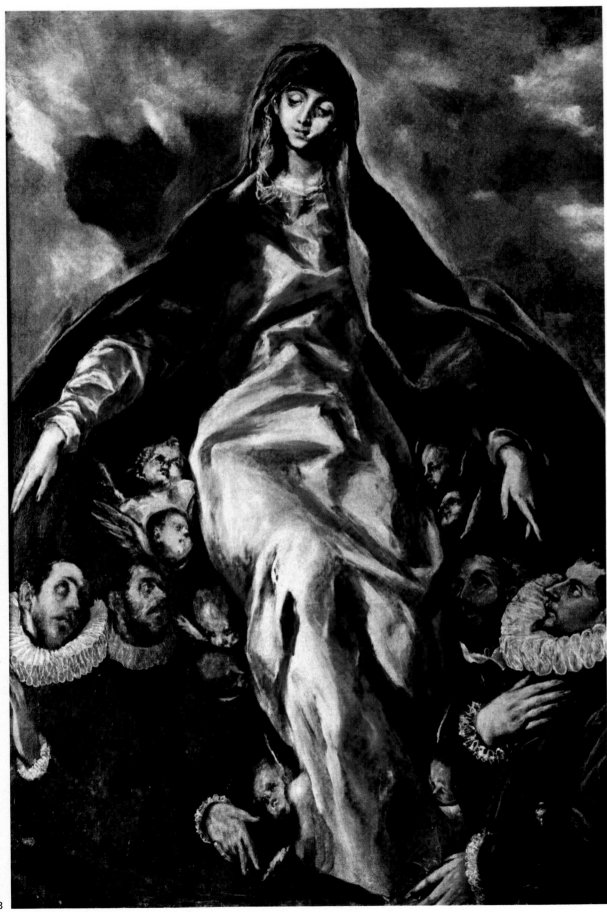

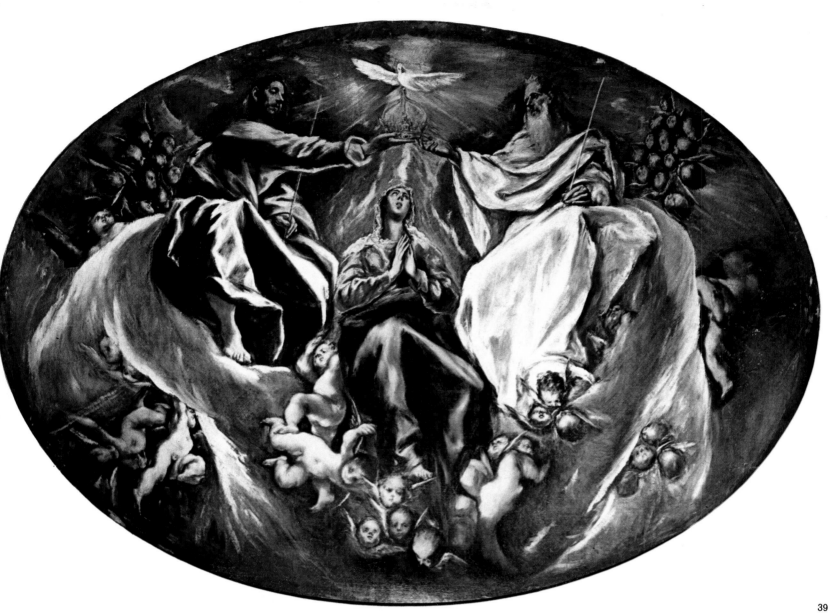

39

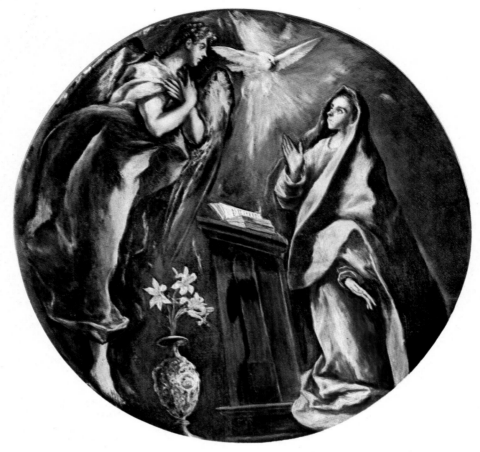

40

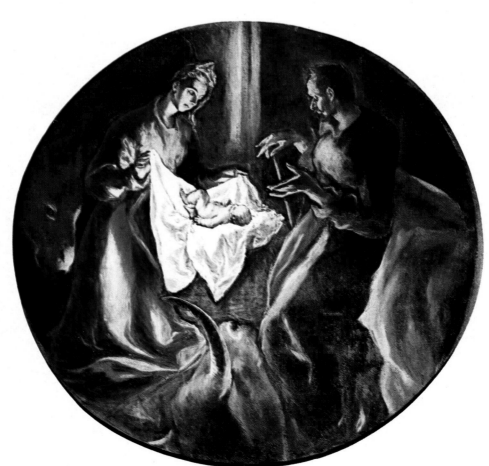

41

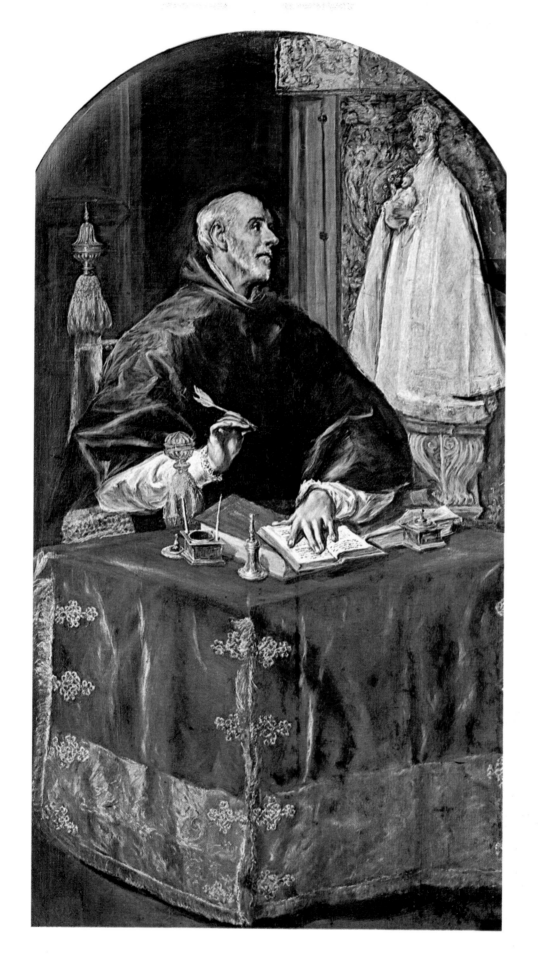

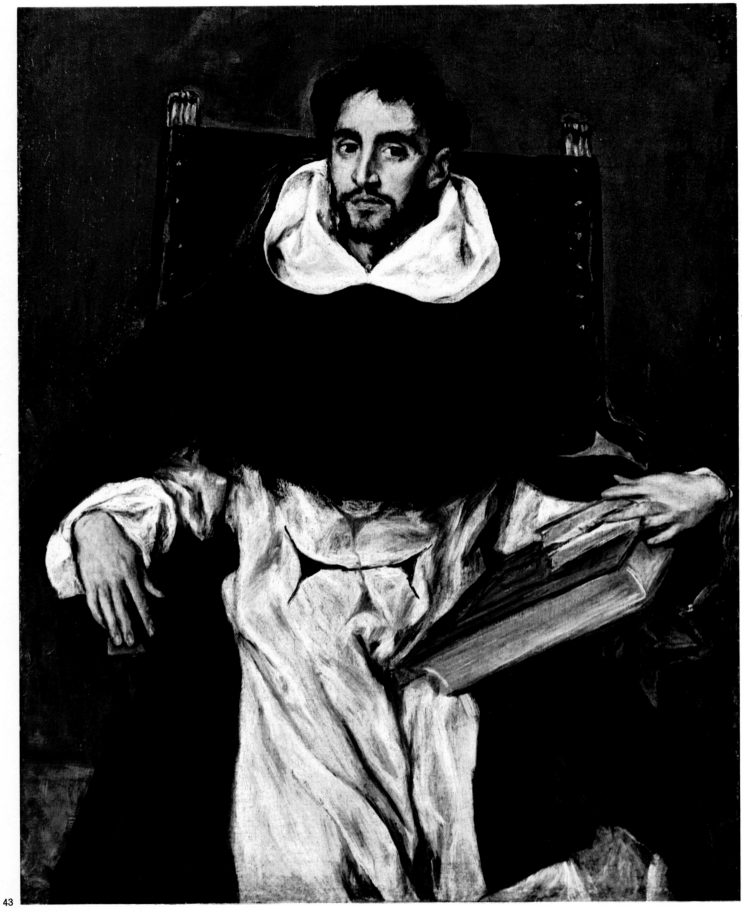

43

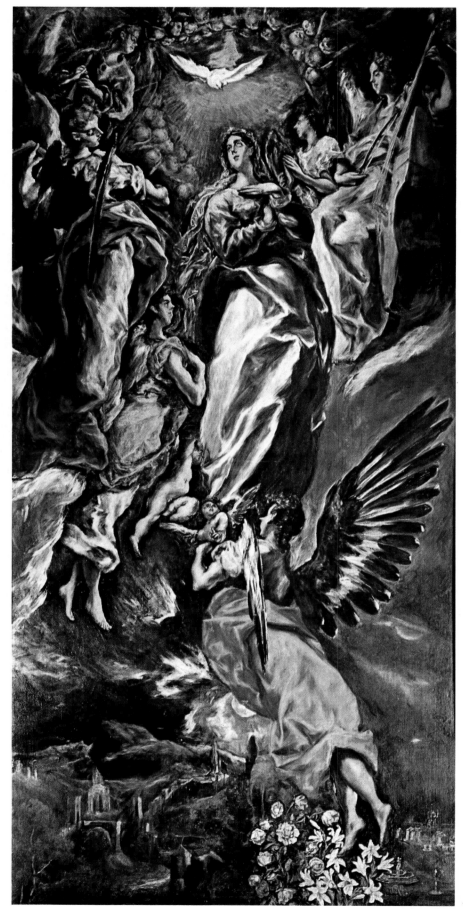

44

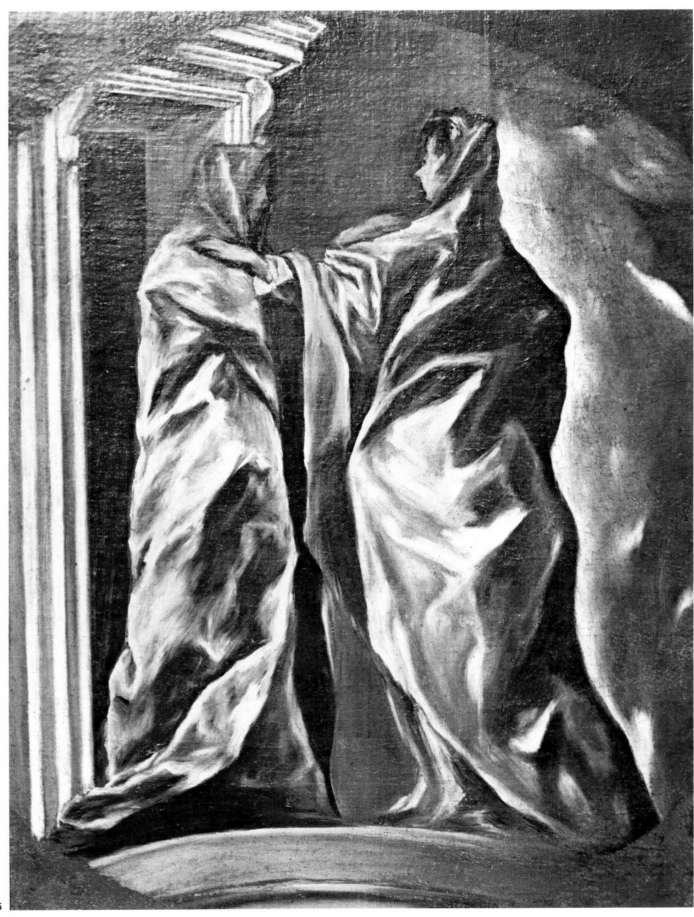

45

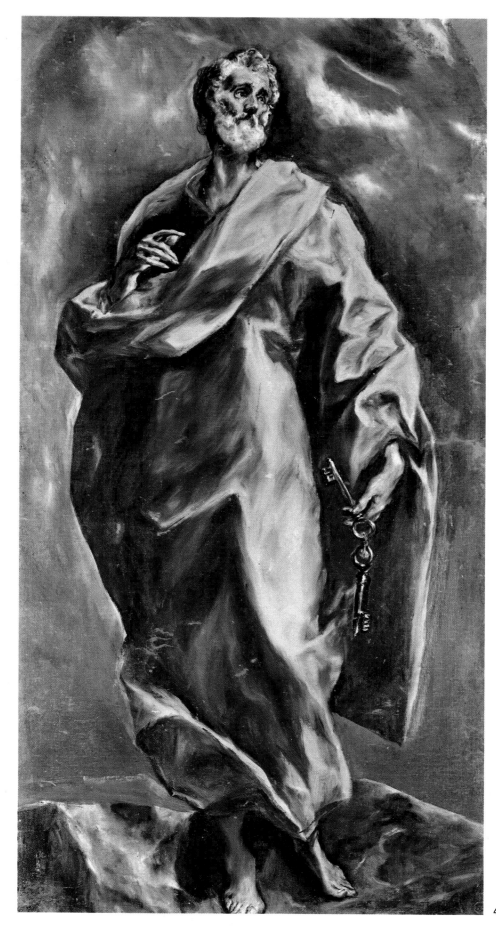

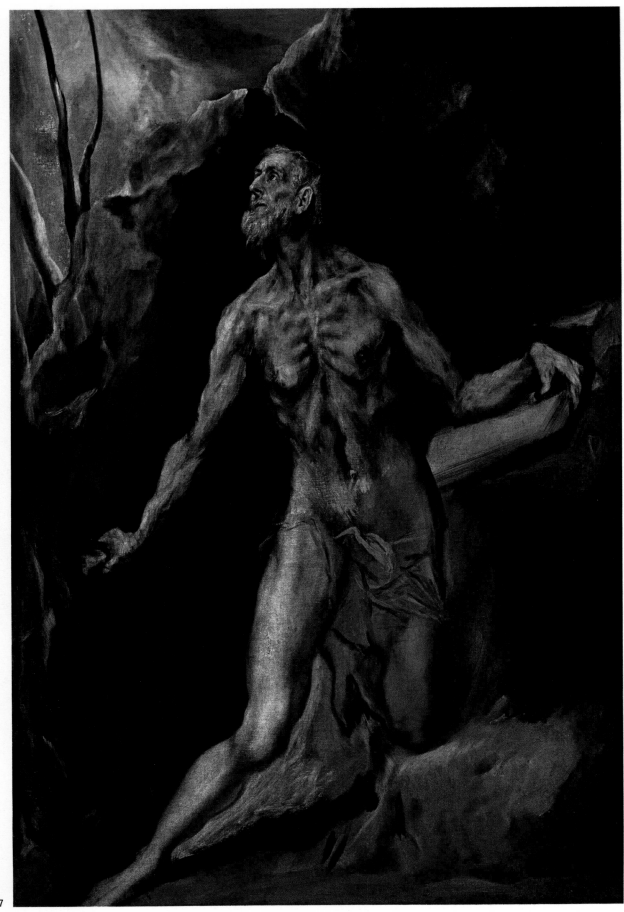

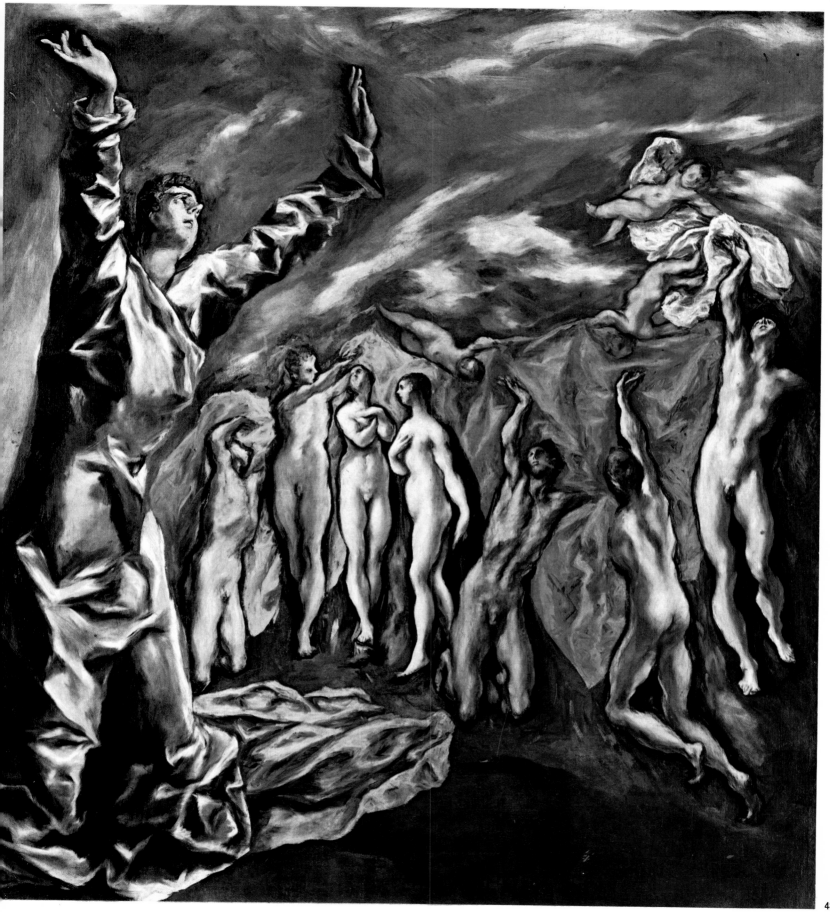

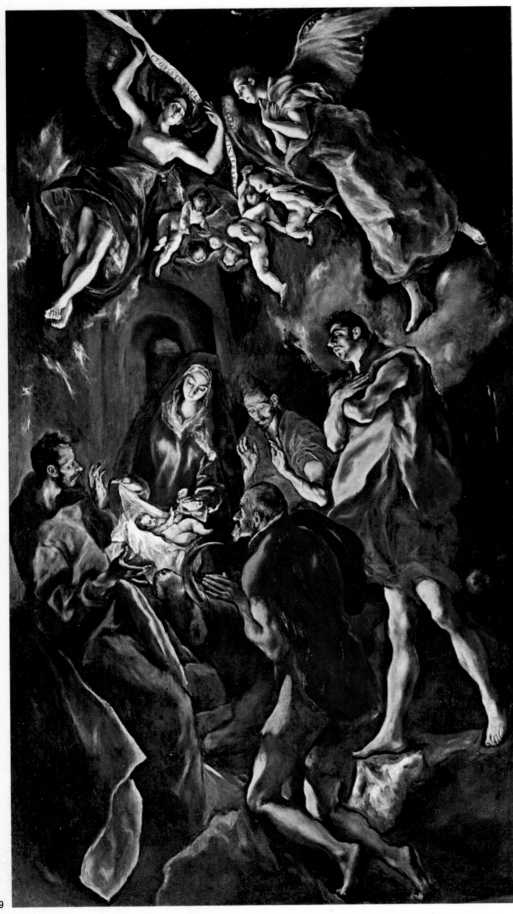